Lighting For People Photography

Stephen Crain

AMHERST MEDIA, INC. ■ BUFFALO, NEW YORK

Published by:
Amherst Media, Inc.
P.O. Box 586
Buffalo, NY 14226
Fax: 716-874-4508

Publisher: Craig Alesse
Editor/Designer: Richard Lynch
Associate Editor: Frances J. Hagen
Copy Editor: Ellen Bumbar
Editorial Assistant/Illustration: Amanda Egner
Editorial Consultant: Dan Schwartz, J.D., Ph.D.
All photos by: Stephen Crain

ISBN: 0-936262-46-X
Library of Congress Catalog Card Number: 96-84426

Printed in the United States of America
10 9 8 7 6 5 4 3 2 1

Acknowledgment: This book is dedicated to my wife and daughter who tolerated hour after month after year of writing and rewriting without nary a whimper, and to my parents who gave me the ability and desire to achieve and pursue that which I love. I also want to thank all the teachers I ever had, from the beginning through college and graduate school, without whose wisdom and guidance I might not have had the self assurance and tenaciousness necessary to complete this project. I would like to thank the advisors who assisted me — Mr. Robert Smith, Mr. Jim Harmon, and Mr. Tony Corbell. These gentlemen provided moral, professional, and educational assistance before, during, and after this project. Support such as this is hard to find and comes from a selfless desire to educate. These men are truly teachers in every sense of the word. Thank you all.

Table of Contents

Introduction

In the early days of photography most work was done with existing natural light because there was almost no use of artificial light. Just as a painter created mood by his careful use of light and shadow, the photographer had to control his use of light and shadow to convey mood, define shape, and examine texture. One major difference was that the painter had an almost infinite amount of time to reproduce or change a painting, while the photographer had to capture an image in a split second.

Photographers often spend too little time learning to understand light, the key element of photography. The purpose of this book is to expose the "secrets" of photographic lighting. After learning to light for people photography, you will have the information you need to control and modify lighting in almost any situation. When lighting becomes second nature, the photographer can spend more time being creative. The result will be better photos, less time spent re-shooting, and greater success capturing photo opportunities.

Use this book to master natural and strobe lighting. This is important for the professional or serious amateur who must make every situation look great, even under changing conditions.

Approach

The text is divided into two sections. Section One explains the principles of light, and Section Two shows how to control the principles. Examples and illustrations demonstrate set-ups and show the results.

By learning how to use and manipulate studio, flash and available light, the photographer will learn how to adapt to a variety of situations and get consistent results.

The Exercises

- Take notes during exercises to help evaluate the results. Write down the number of the frame and pertinent lighting, set-up, and equipment information.

- Slide film is suggested for all of the exercises in this book since it is processed without regard to individual frame exposure or color balance. Color prints, on the

• **The purpose of this book is to expose the "secrets" of photographic lighting.**

other hand, may be individually altered in processing, and this will affect accuracy in testing.

The exercises found at the end of each chapter are designed to help readers practice the techniques they'll need to remember. It also allows the reader to be sure he or she understands the concepts before moving on to the next chapter.

Each exercise lists the supplies you'll need and provides step-by-step instructions. Approach each exercise as you would an actual shoot, and bracket ■ your shots using different apertures and shutter speeds.

Take detailed notes during the exercises. The notes should include rough diagrams of the lighting set up which you can use to help evaluate the results. Since you might make many exposures for any one exercise, it is important to make notes so that you don't forget important details of the setups.

■ BRACKETING

Bracketing exposures means taking exposures in a range above and below the metered exposure to capture the best possible result.

For our purposes, a bracket series should include seven exposures at three 1/3 stop increments below and above the metered exposure.

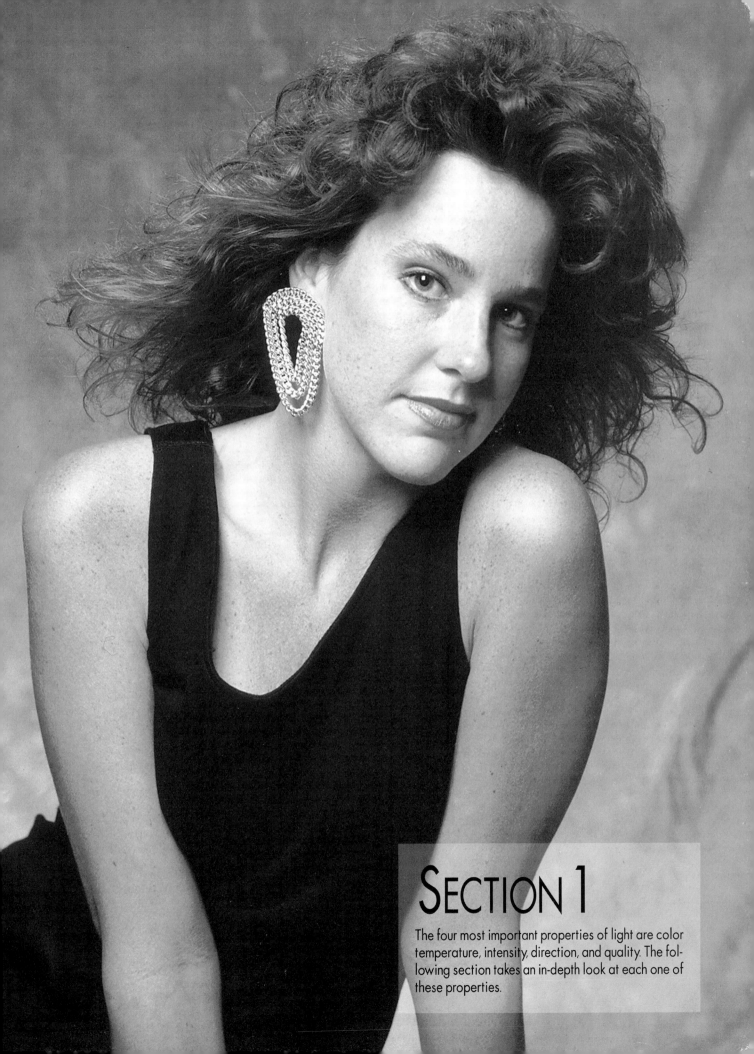

SECTION 1

The four most important properties of light are color temperature, intensity, direction, and quality. The following section takes an in-depth look at each one of these properties.

CHAPTER ONE

Color Temperature

The first property of light to be discussed is color temperature ■. All light has a color temperature which can be measured and stated in terms of degrees Kelvin. The higher the color temperature of a light, the cooler or bluer that light will appear. Conversely, the lower the temperature, the warmer or redder it will appear. The color temperature of light can change in a scene at any time, and this will affect your photography. For that reason, it is important to understand what color temperature is and how it affects lighting for people photography.

Color temperature is the balance of colors in light. For example, natural light is the combination of skylight (diffused light from the sky) and direct sunlight. Skylight is comprised primarily of blue light, and it is quite a bit cooler than direct sunlight.

For the sake of photography, "neutral" light is approximately 5,500 degrees Kelvin. Skylight, i.e. an overcast day with no direct sunlight, at sea level, has an average color temperature of approximately 8,000 degrees Kelvin. Sunlight has an average color temperature of 4,500 degrees Kelvin.

Neutral or white light is lighting that is comprised evenly of all the colors in the light spectrum. In other words, it is a mixture of all the wavelengths of light. Such differences may not be perceived by the naked eye: our eye will compensate for lighting conditions where film will not. Taking pictures under light that is different from white will result in tinted pictures.

For example, if we photographed someone using fluorescent light, the image might appear palatable to the naked eye, but the film result will show green-tinted flesh tones. Without a proper meter, there is no way for the photographer to know the exact color temperature.

The color temperature of light depends on its source. Anything that light passes through or bounces off of, between the source and the subject, can affect the light's color temperature. The photographer needs to remain aware of color shifts and learn how to use them to his or her advantage by altering the color temperature of light. This will produce stronger images.

"THE COLOR TEMPERATURE OF LIGHT DEPENDS ON ITS SOURCE."

Factors Affecting Natural Light

The color temperature of natural light changes throughout the day. The prime factors affecting the change in color temperature are: the time of day, atmospheric conditions, and elevation.

Early and late in the day, when the sun is positioned closer to the horizon, sunlight passes through more atmospheric interference (smoke, smog, fog, dust). Such interference scatters the blue component of sunlight more than the red. Because the blue component disperses, this light shifts toward red.

Near midday, the sun has less atmosphere to pass through and scatters less of the blue component. The light is not only bluer (cooler), but more intense as it rises in the sky. The temperature of daylight is lowest at sunrise (about 3,200 degrees K) and sunset (about 3,500 degrees K). The peak temperature of the day averages between 5,500 and 6,500 degrees K.

Cloud cover affects the color temperature of light in a similar way to atmospheric interference; however, clouds actually block direct sunlight from reaching the ground. This allows the skylight, which is always present, to have a greater influence which then cools the daylight temperature. As cloud cover increases, the color temperature of midday natural light can rise as much as 2,000 degrees.

Elevation also affects the color of natural light. At higher elevations, the air becomes thinner and contains fewer light-scattering particles. Because the blue component has less chance to scatter, the light is cooler. You may have to compensate for this increased blue light with a skylight filter.

- **You must be aware at all times of influences affecting the color temperature of the light you are using.**

Much outdoor photography is done during late morning and early afternoon. Due to the shadows caused by direct sunlight, afternoon shoots are often done in open shade. Because shaded sunlight contains more skylight, it is bluer (cooler) and may require filter compensation.

Artificial Light

Common light bulbs, open flames, quartz lamps, vapor lamps, and fluorescent lights are forms of artificial light. Each of these forms has specific characteristics. Household light bulbs not only vary in brightness, but come in a wide range of color temperatures from 2,500 to 3,400 degrees Kelvin.

When using these bulbs with daylight-balanced film and no color correction, the photo results will be warm. When using household bulbs with T-type (tungsten) film, the results will be normal or slightly warm.

Firelight (light from a candle or fireplace) produces a color temperature between 1,800 degrees and 2,600 degrees Kelvin. Much like household bulbs, firelight produces a very warm (reddish) look when used with daylight-balanced film. To compensate, you need to use tungsten film or place a cooling filter on your lens.

The lighting in parking lots and on buildings is often high-intensity sodium or mercury vapor lamps. These lamps produce light which is green, yellow, or reddish-orange and is generally unacceptable for photography. No standard filters are available for use with these light types. If you must shoot under them, use print film, and tell your printer to color balance your prints.

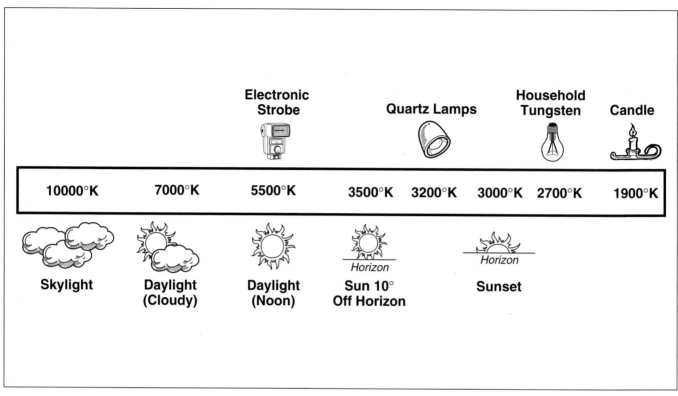

Color temperatures of artificial and natural sources are shown in the above diagram. The average color temperature for noon daylight is 5,500 Kelvin. When the sun is 10° off the horizon, the color temperature is approximately 3,500 Kelvin. Skylight produces a color temperature of 10,000° Kelvin. An electronic strobe, an artificial source, has a color temperature of 5,500 Kelvin, while the household tungsten light has a temperature of 2,700 Kelvin.

• **Always plan ahead and be ready to shoot before you find out that you don't have the film or other supplies you need.**

■ **STROBE LIGHTING**

Electronic flash lighting which has the ability to discharge and recycle rapidly. Most will cycle once or twice per second.

Sports arenas often use multi-vapor lamps. These have a more continuous color emission than sodium or mercury vapor lamps. When used with print film, the color shift may be filtered during printing to produce acceptable results.

If using slide film, a color test can determine the appropriate filtration. To do this, shoot a roll of film at the site under the same conditions before the planned shoot. Have it processed to determine if the lighting is acceptable.

Color Balance of Film Emulsions

All color films (slide or print) perform best in their specific color temperature range. Emulsions come balanced for one of three color temperatures: Daylight, balanced for 5,500 degrees Kelvin; Tungsten type A, balanced for 3,400 degrees Kelvin; and Tungsten type B, balanced for 3,200 degrees Kelvin. As tungsten type B is far more common than type A, all reference to tungsten film in this text pertains to type B.

Most photographers use sunlight and/or daylight-balanced STROBE LIGHTS ■ for the majority of their work. With this type of lighting, film balanced for daylight is most commonly used.

Some photographers choose to use "hot lights," which are photographic tungsten lights. In this case it is best to use tungsten film. The selection of film is entirely up to the photographer, but one should base the selection on the conditions and needs for a particular assignment.

The Minolta Color Meter II.

- **Color temperature meters do not give reliable readings when used with light sources that are non-continuous spectrum sources.**

Color filters — glass and gelatin.

Color Temperature Meters

With experience, a photographer can tell the temperature of natural light based on the season, time of day, and atmospheric conditions; however, for balancing light so that it looks consistent throughout an entire day of shooting or between sessions, a color meter is essential. Simple color meters take color temperature readings of continuous light sources. More sophisticated meters take readings of ambient lighting and strobe lights. Both meter types are very similar in design. To take readings, place the meter near the subject and point it in the direction of the light source.

Reflectors, tungsten bulbs, strobe tubes, photographic umbrellas, and soft boxes change temperature throughout their useful lives. Accessories generally warm as they age. Warming is due to physical changes in the equipment and its surfaces, including the accumulation of dirt.

A color meter allows the photographer to note changes in the performance of light sources and accessories; however, color meters are also expensive. Most professional photographers don't own one and rely instead on experience and good luck.

Correcting Color Temperatures

Color temperature meters have reference charts which show how much filtration is needed to change the temperature of a light source. This can be accomplished through altering the light as it leaves the source or as it enters the lens by using filters or gels.

Color correcting filters come in four main series: 80, 81, 82, and 85. The 81 and 85 series are warming filters, and the 80 and 82 series filters cool color temperatures. Letters identify the degree of filtration of a given filter. For example, an 81A filter has less effect than an 81B, and the 81B has less than an 81EF.

Color filters come in various sizes, colors and densities. Filter sheets are thin and are made of acetate or gelatin. They can be cut or used whole. If placing a filter over a continuous light source, be sure the filter is intended for use at high temperatures. Filters can also be combined to achieve specific color temperatures.

Lens filters are used to change overall color temperature rather than to modify light sources. The result is similar, but filtering a lens may result in bad meter readings. If you are not using in-camera metering, you may need to compensate for the filter. A filter factor, provided with each filter, can be used to correct exposure. Filter factors are not important when using gels on a light source because the scene itself changes. These changes are picked up by meters. Meter readings might be affected by certain color filters, and this will result in underexposure. Test new filters before you use them on an important shoot. Use only as many lens filters as necessary.

Even though most glass and gelatin filters are optically pure, using more than two can have a negative effect on the quality of the final image. Another method of filtration is to cut the gelatin filters to fit the lens being used. These filters can be secured between the skylight or UV filter and the front of the lens. Use a lens hood to eliminate reflections on the gels.

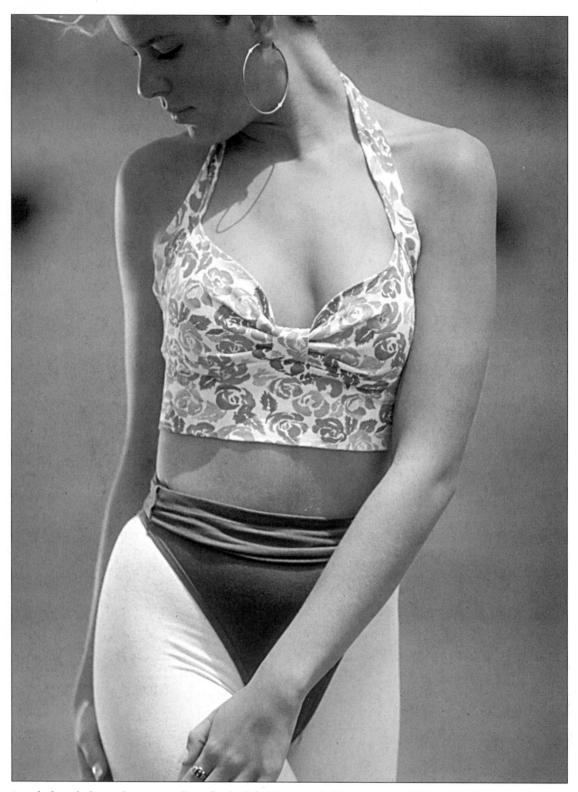

I took this clothing shot at a college football field. Direct lighting was used from the front and left side of the model to bring out the texture and color of the garments, The model was lit from behind with a gold reflector to provide separation from the shadows.

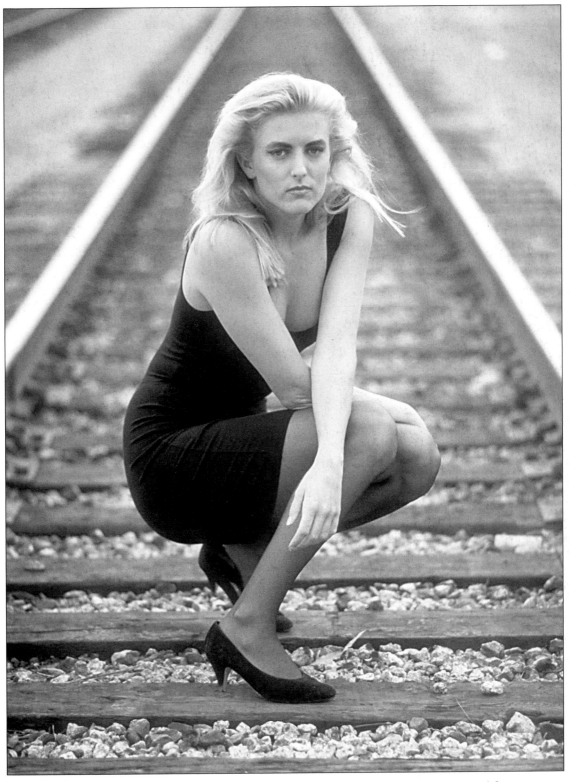

This shot was taken on railroad tracks between passing trains. On a heavily overcast California morning, I used the soft diffused light to provide backlight and shadowless key light.

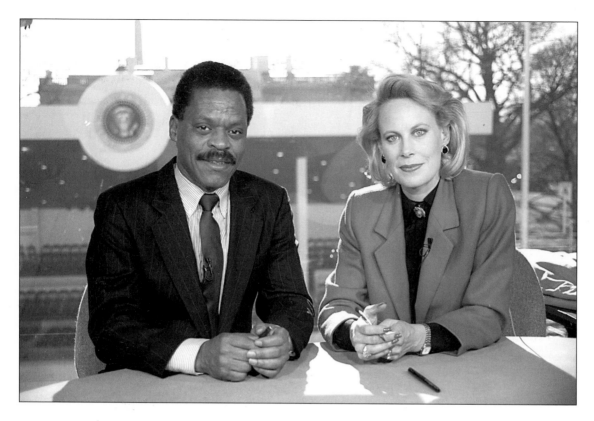

Above: *While on assignment for CNN in 1988, I photographed news anchors Bernard Shaw and Mary Alice Williams while they covered the Presidential election. This photograph was taken under tungsten television lighting. Because this photo was taken with print film, no filtration was required. All filtration was done during printing.*

Below: *A white sheet was hung over the subject to diffuse the midday light. This photograph was taken with a Bronica ETRS and 80mm lens set at 1/500 sec. and f/4.0 to soften the background.*

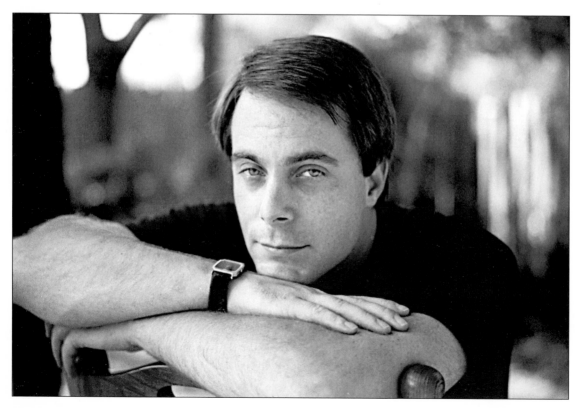

Chapter One Exercises

EXERCISE I: CHANGING COLOR TEMPERATURE

Objective: To observe how the changing color temperature of daylight affects photo results.

Supplies needed: Camera and lens, tripod, model, one roll of daylight-balanced slide film

Instructions:

1. Set aside a time so all phases of this exercise can be performed in a single day.

2. Find a convenient location which will receive direct, unobstructed sunlight throughout the day.

3. Set up the camera on a tripod.

4. Place your model so he or she is illuminated by direct sunlight. Face the model north or south.

5. Make a series of exposures one hour after sunrise.

6. At midday, return to the exact location of the first exposures, and make another series.

7. Take a third series of exposures one hour prior to sunset.

8. Have the film processed at a color laboratory and examine the differences between the transparencies on a color-balanced light box.

 Note the differences in the color of the three series of photographs. Pay special attention to the tint of the model's skin tones.

EXERCISE II: DIFFERENCES OF COLOR TEMPERATURE

Objective: To examine the difference between color temperature in direct sunlight and open shade.

Supplies needed: Camera and lens, tripod, model, one roll of daylight-balanced slide film, one 81B filter (glass or gelatin)

Instructions:

1. Find a single location with useful shooting areas in both direct sunlight and open shade.

2. Take a series of exposures of a subject illuminated by direct sunlight with no lens filtration.

3. Take a series of exposures under the exact same lighting conditions with an 81B filter over the camera lens. Be sure to compensate for the filter (1/3 stop).

EXERCISE I — SUPPLIES

☐ Camera and lens
☐ Tripod
☐ Model
☐ One roll of daylight balanced slide film

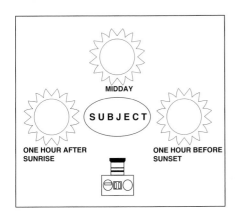

EXERCISE II — SUPPLIES

☐ Camera and lens
☐ Tripod
☐ Model
☐ One roll of daylight balanced slide film
☐ One 81B filter (glass or gelatin)

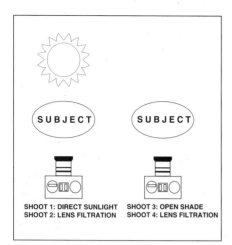

SHOOT 1: DIRECT SUNLIGHT SHOOT 3: OPEN SHADE
SHOOT 2: LENS FILTRATION SHOOT 4: LENS FILTRATION

EXERCISE III — SUPPLIES

❏ Camera and lens

❏ Tripod

❏ Model

❏ One roll of slide film

❏ Color temperature meter

❏ Flash meter

❏ Light stand

❏ One sheet orange warming and blue cooling filters

4. Place the subject in the open shade so that he or she receives no direct sunlight.

5. Make a series of exposures with no filter on the camera lens.

6. Make a second series of exposures in this same location using the 81B filter.

7. Have the film processed at a color laboratory and examine the differences on a color-balanced light box. Note the degree of warming of the subject's skin tones between the first two series of exposures. Next, compare color difference in the direct sunlight and open shade photos made without filtration. Finally, compare the change that happens when the warming filter is applied in your open shade series.

EXERCISE III: EFFECT OF FILTERS

Objective: To show the effect of filters on the quality of strobe lighting in flash photography.

Supplies Needed: Camera and lens, tripod, model, one roll of slide film, color temperature meter, flash meter, light stand, one sheet (12" x 12") orange warming and blue cooling filters.

Instructions:

1. Set up your equipment and model indoors in an area where there is little or no ambient light.

2. Place your model on a chair or stool and set the camera on a tripod in front of the model.

3. Place an on-camera strobe or studio strobe unit on a light stand and direct the light at the model.

4. Set your strobe on automatic, and use a color temperature meter to take a reading of the unmodified strobe light.

5. Make a note of the readings for use in comparing later readings in this exercise. **Note:** If you do not have a meter, you will not be able to compare meter readings, but the results will still work for the purpose of this exercise.

6. Adjust aperture and shutter speed accordingly.

7. Take a series of exposures using the unmodified strobe light.

8. Place a strip of warming filter material (gelatin) over half of the strobe tube. Be sure not to cover the intensity sensor on the front of the flash unit.

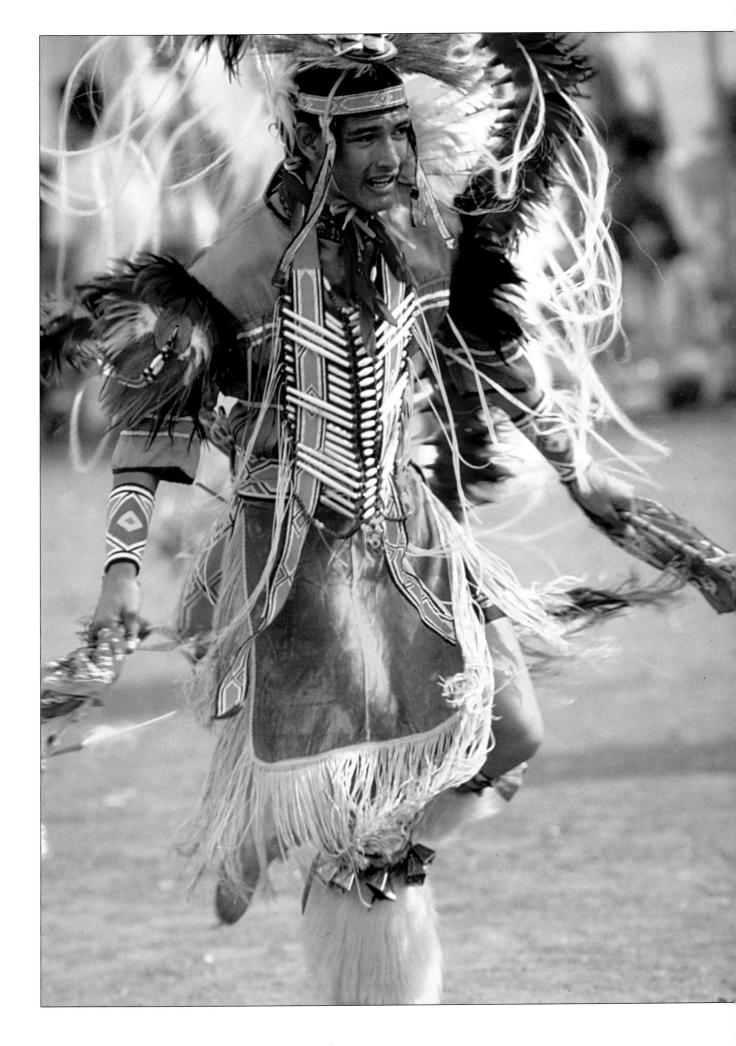

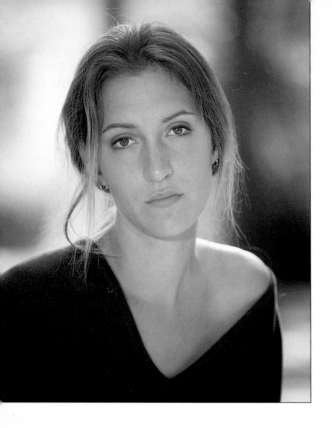
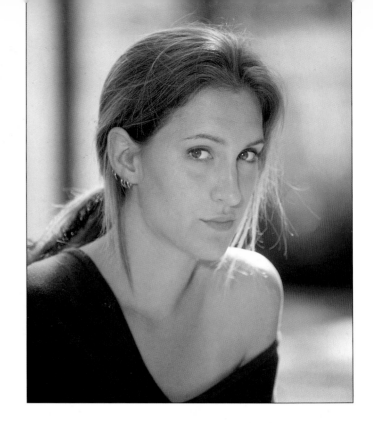

Previous page: This Native American dancer was photographed at a Southern California Pow Wow. I used direct sunlight to side light the dancer to examine the textures and vivid colors of the costume. The dancer was photographed with a Canon 300mm f/2.8L lens to isolate the dancer from his environment.
Above, left: This photo was taken with unmodified strobe light balanced to 5,500 degrees Kelvin.
Above, right: Here, the modified strobe light was balanced to 4,500 degrees Kelvin by placing a gel filter over the strobe.
Below, left: This photo was taken with natural daylight in open shade at 6,800 degrees Kelvin.
Below, right: With on-lens modification, the open shade in this photo was warmed to 4,500 degrees Kelvin.

Left: *This swimwear shot was taken in Santa Barbara, California by the old bath houses near Montecito. Using directional afternoon daylight for a main light and a gold reflector for edge definition, I also used an 81E filter for warmth. A Canon EOS 1 and 300mm f/2.8L lens was used.*

Below: *Taken on the Riviera in Santa Barbara, California, this fashion photo uses shadow and contrast to create the mood. A Canon EOS 1 and 80-200mm lens were used. Camera settings were 1/125 sec at f/4.0.*

Left: This is an example of glamour lighting using two lights. One light was set to camera left and the other was placed to camera right. Both lights were adjusted to provide even illumination of the model to create soft shadowless light. Both lights were used in umbrellas which had diffusion panels over the front to soften the light even more.

Right: This location family portrait was made with three lights. Two were used to light the group from the front, one to camera right and the other to camera left. These lights were placed in diffused umbrellas. The third light was a bare bulb used from behind to provide hair light and separation from the background. A Hassleblad 500c/m and 180mm lens were used.

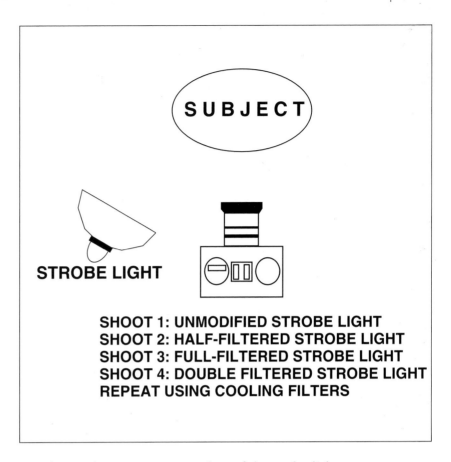

SHOOT 1: UNMODIFIED STROBE LIGHT
SHOOT 2: HALF-FILTERED STROBE LIGHT
SHOOT 3: FULL-FILTERED STROBE LIGHT
SHOOT 4: DOUBLE FILTERED STROBE LIGHT
REPEAT USING COOLING FILTERS

9. Take a color temperature reading of the strobe light. Note the reading for later reference, and do not make any adjustments.

10. Make a series of exposures.

11. Completely cover the strobe tube with the filter. Again, take color temperature and intensity readings of this light.

12. Take a series of exposures.

13. Double the gel over the entire strobe tube, and make the necessary meter readings.

14. Make a series of exposures.

15. Repeat steps 8-14 using cooling filters.

16. Have the film processed and look at the differences between the unmodified light and the modified exposures. Note the effects of warming and cooling filtration over the light source at each stage. If you used a color temperature meter, compare the readings you took to the results on film.

Light Intensity

The second property of light is intensity. Measuring intensity and understanding how to harness the light source that you are using is crucial to achieving consistent exposures. The intensity of light is expressed as a shutter speed/aperture ratio. The expression of this ratio will be relative to a specific film speed.

For example, at noon on a sunny day, the light's intensity may be f/16 at 1/125 second with ISO 100 film. This same light would have an aperture/shutter speed ratio of f/2.8 at 1/4000 second with the same film.

The intensity of natural light will vary with the position of the sun and decrease when any obstructions are introduced between the light and your camera. To measure the intensity of light, you should use a light meter.

Inverse Square Law

Light intensity decreases as a subject moves further from the source. The *INVERSE SQUARE LAW* ■ relates the distance of a subject from a source to the intensity of light striking the subject. (*See diagram on next page.*)

Simply stated, the law says that each time the distance from the light source doubles, one fourth the light reaches the subject. For example, a subject 10 feet from a light source will receive 1/4 as much light as a subject 5 feet from the same source.

Film speed

Photography depends on the ability of film to capture and record light. Some film types will record better in low light, while others perform well in high intensity light. A film's *latitude* is its tolerance to handle over or under exposure.

Film's sensitivity to light is indicated by ASA (American Standards Association), DIN (German Industrial Standard), or ISO (International Organization for Standardization) ratings. For the purpose of this text, film light sensitivity is stated in terms of ISO.

"UNDERSTANDING HOW TO HARNESS THE LIGHT SOURCE YOU ARE USING FOR YOUR PHOTOGRAPHY IS CRUCIAL..."

■ INVERSE SQUARE LAW

A physical law which states that the intensity of illumination is inversely proportional to the square of the distance between the subject and the light source.

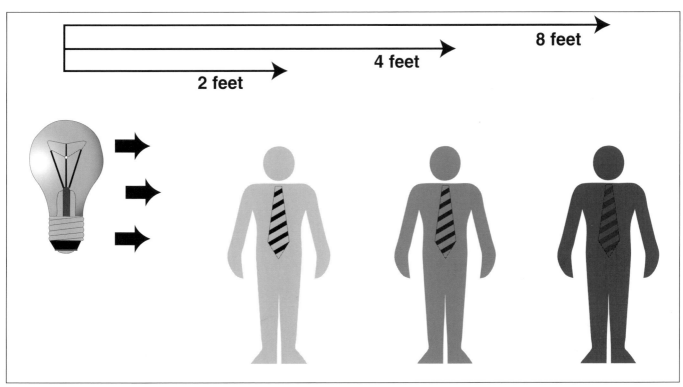

2 feet

4 feet

8 feet

The above diagram illustrates the Inverse Square Law. The law states that each time the distance from the light source doubles, one fourth the light reaches the subject. For example, a subject 8 feet from a light source will receive 1/4 as much light as a subject 4 feet from the same source. A subject 4 feet from a light source will receive 1/4 as much light as a subject 2 feet from the same source.

With ISO measurement, the smaller the rating number, the slower the film. A faster film will require less exposure than a slower film in the same lighting conditions. ISO film ratings denote 1/3 f-stop increments, and range as follows: 25, 32, 40, 50, 64, 80, 100, 120, 160, 200, 250, 320, 400, 500, 640, 1000, 1200, 1600, and 2000 speed. The 1/3 stop variance may not seem like much, but with slide film it can mean the difference between a great photograph and one which is unusable.

If you are going to be working in low light conditions, such as at dawn or dusk, you should use faster film. This will allow you to select shutter speeds which will stop motion or blurring. A film speed of ISO 400 is good for early or late in the day, while a film speed of ISO 160, 100, or 25 may be appropriate with strobe lighting or at midday.

Testing ISO

Film speeds within families (i.e.: Ektachrome or Kodachrome) are very consistent; however, for professional and serious amateur use, a photographer should test specific film types before important projects. Most film manufacturers overrate their films. Additionally, in-camera and hand held meters may be adjusted differently than the instruments used to calculate the ISO of the film.

The objective of testing is to know the *exact* ISO rating. Once the ISO rating has been determined and the light intensity is measured, proper exposure can be calculated. To do this test, photograph a subject in a lighting

Specific film types should be tested for the exact ISO rating before important projects.

situation similar to one you will be shooting, and inspect the results. Be sure to take notes on all the exposures.

Steps:

1. Have the model hold a photographic 18% gray card below his or her chin.

2. Set your hand-held light meter (or in-camera meter) one full f-stop faster than the rated film speed. For example, if you have a film which is rated at ISO 100, set your meter or camera to ISO 200.

3. Take a photograph of your model.

4. Reset your meter for ISO 160 (1/3 stop slower), take another reading, adjust settings and make another exposure.

5. Repeat step 4 changing the settings in 1/3 stop increments until you have reached one full f-stop below your film's rated ISO. In this example, the exposures would reflect ratings of ISO 50, 64, 80, 100, 120, 160, and 200.

6. Have your film developed (using the same process and lab you intend to use), and inspect the results. The model's skin tone and the gray card should appear accurate in one of the exposures. The ISO rating at which you achieved

*Left: Proper Exposure. Note the full texture and detail in the subject's skin and clothing. **Center:** Overexposure. Photograph from a slide overexposed by 2/3 f-stop. Note the decreased saturation in the model's clothing and the lack of detail in the model's skin. **Right:** Underexposure. Photograph from a slide underexposed by 2/3 f-stop. Note the overall lack of detail in the photograph.*

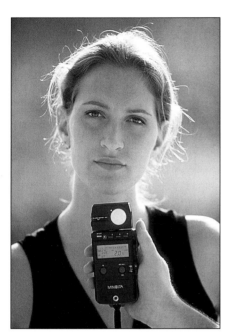

This incident light meter is shown properly used. The diffusion dome is held at the model's position and directed at the camera.

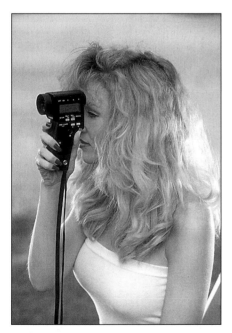

Reflected Light Exposure Meter, Minolta Spot Meter F. The spot meter is used remote from the subject and directed at a small area to be metered for correct exposure.

the proper density should be the ISO at which you rate this film in the future.

A more scientific way to get accurate results is to follow the steps above and have the film lab do a density test on the gray card in the exposures. They will use a densitometer to determine which exposure resulted in the proper density of the gray card.

After you have the densitometer readings, you can go back to your notes and correlate at which ISO rating the proper density was achieved. Many photographers will test their film regularly to assure the film remains consistent from batch to batch.

Exposure settings

A variety of shutter speeds and apertures result in the same exposure. For example, an aperture of f/8.0 at 1/125 second will render the same exposure as f/5.6 at 1/250 second and f/16.0 at 1/30 second. The difference between the various combinations are: the effect on depth of field (for aperture changes) and action-stopping ability (for shutter speed changes).

The larger the aperture opening, the shorter the depth of field. For example, a setting of f/2.8 will have less depth-of-field than f/11.0. The corresponding change in shutter speed may give you a blurry image if your shutter speed is too slow.

For people photography, it is advisable to use shutter speeds of 1/125 or faster. Slower shutter speeds are more useful with a tripod and a stationary subject.

Metering Light Intensity

Exposure meters measure the amount of light in a scene and help determine accurate camera settings. Meters show exposure time and aperture, based on film speed. Two different types of metering commonly used are incident metering and reflected light metering.

An incident light meter works by measuring the intensity of the light reaching the subject, and is designed to measure light from the position of the subject. The meter is held near the subject and directed toward the main light source.

If the light source is identical to the light falling on the photographer, the photographer can take the reading from the camera position. If metering a specific source, it is important not to allow light from other sources to influence the meter. To ensure that the light reading indicated by the meter is for one specific light, use a hand to block stray light from striking the diffusion dome.

The advantage of an incident meter over a reflected light meter is that it is easier to interpret its readings. This is because you are reading the light reaching the subject and not the light reflecting off the subject.

Reflected light meters measure light reflecting from a subject. All in-camera meters are reflected light meters. Separate, hand-held meters of this type are also available. All reflected meters are programmed to give an exposure

■ 18% GRAY CARD

The average reflectance of any scene of normal tonality should be about 18%. We use cards with 18% reflectance (gray cards) to represent and reflect the average tones of a scene.

The reason for gray is because it is neutral — colors would tint reflected light and might affect meter readings.

value which will result in an "average" exposure of the scene being metered. The scene will be metered to render an average tonality of *18% GRAY* ■.

For example, if a reading is taken of a black card, the image of the black card will be exposed to 18% gray. If the same intensity of light is metered off a white card, the white will also be exposed to 18% gray.

Hand-held spot metering is done from the vicinity of the camera so the meter "sees" the same light as the camera lens. Rather than reading a broad scene, as in-camera meters do, these meters measure only at 1 or 2 degree angles. This makes them useful when a photographer must take an exact reading from a remote site.

There is no difference in the photographic results when using either a reflected or incident light meter. The difference is in interpreting the readings. Readings for incident meters remain the same regardless of the subject. However, a reflected light meter would read differently when pointed to various objects in a scene.

Most incident meter manufacturers also make 5 degree spot attachments which allow the user to take spot-type readings. When using a spot-metering attachment on an incident meter, use it as you would a regular spot meter.

Metering for People Photography

An incident meter is most often used for people photography; however, using a spot meter and an 18% gray card will produce good tonal results. If you work with only an in-camera meter, use an 18% gray card.

An incident light meter was used to determine the correct exposure.

Reflected light exposure using a gray card resulting in proper exposure.

Reflected light exposure using a white card. When using a white card to determine exposure with a reflected-light exposure meter, use camera settings two stops down from the indicated exposure value.

Reflected light exposure using a black card. If using a black card to determine exposure with a reflected-light exposure meter, use camera settings two stops up from the indicated exposure value.

"THERE ARE SEVERAL WAYS TO CONTROL THE INTENSITY OF LIGHT."

Controlling Light Intensity

There are several ways to control the intensity of light used for photography: the subject can be moved into different light; light can be blocked (using a scrim or gobo); light can be added using reflectors; or when portable, the light sources can be moved closer to or farther from a subject.

The simplest way to increase or decrease intensity is to move a subject. Moving to a shaded area from one with direct natural lighting will decrease intensity. Likewise, moving away from a shaded or indirectly lighted area will increase intensity.

Another solution is to turn the subject so that the light strikes him or her differently. If the location or the lighting dictates that the subject remain where he or she is, light reflectors or blocking tools can be placed to increase or decrease exposure.

Scrims reduce light by diffusion, while gobos completely block direct light. Scrims are made out of black mesh material resembling door screens. They come in different light blocking ratings measured in stops. Gobos can be made of anything which will block light from reaching the subject.

Light can be redirected to a subject using mirrors or photographic reflectors. A very popular reflector material is foam core board (available from art supply stores). It is highly reflective, lightweight, cheap, and you can easily cut it to various sizes. If a transmission panel or reflector is used, it is important to know the color balance of this source and to correct for it, otherwise it will affect the final color temperature of the photos.

■ DEPTH OF LIGHT

The distance behind a subject at which point the exposure value begins to fall off noticeably.

Depth of Light

DEPTH OF LIGHT ■ is tied directly to the inverse square law. Depth of light refers to the distance (depth) in front of and behind a point wherein the intensity of the light remains the same as the light striking that point. It is often desirable for the exposure value on a subject to be greater than, less than, or equal to the exposure value of the surrounding area.

The two ways of controlling depth of light are: change the light-to-subject distance, or change the distance between subject and background.

With frontal lighting, the background will receive less light than the subject. The greater the distance between subject and background, the greater the rate of light fall-off behind the subject.

When the distance between the subject and background remains constant, and the light source is moved farther away, the exposure difference between the subject and background decreases. Therefore, moving the light source back is one technique to decrease the subject-to-background lighting ratio.

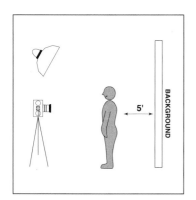

Left: Setup

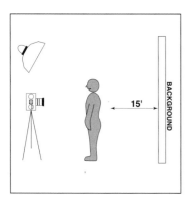

Right: Setup

In the photo above, the light source is 5 feet from the subject, and the exposure difference between the subject and the background is one stop.

With the light source 15 feet from the subject, the exposure values for the subject and the background are equal. Compare with the photo on the left and note the difference in background tonality.

Chapter Two Exercises

EXERCISE I: EFFECTS OF OVER AND UNDER EXPOSURE

Objective: To show the effects of over and under exposure on an ISO tested film stock.

Supplies needed: Camera and lens, model, tripod, one roll of each specific film to be tested (This test can be done with daylight, strobe, or hot lights, but use the appropriate film for your light source.), an 18% gray card, light meter (incident or spot), notebook.

Instructions:

1. Face the model into the light source. This can be outdoors, indoors next to a window, or using electronic strobes or flash. Have the model hold an 18% gray card just below his or her chin.

2. Set your meter one full f-stop over the film's rated ISO.

3. Take a light reading. If you are using a reflected light meter, take a reading from the card. If you are using an incident light meter, take the reading from directly in front of the card. If using an in-camera meter, remove the camera from the tripod and bring it close enough so the gray card fills the entire viewfinder, but be careful not to block any light from hitting the card.

4. Set up the tripod and camera so that the gray card fills 50 percent of the viewfinder and the subject's head fills the remainder.

5. Note the indicated aperture and shutter speed in your notebook.

6. Make a series of exposures.

7. Have the film processed at a laboratory and examine the results. Either examine by eye or have densitometer tests run at the laboratory. The proper densitometer reading for the gray card will be .80 when using slide film, and the proper density for the gray card reading on color negative film will average around .86. (It may vary for different film stocks.) For black and white film the proper density should be around .70. Carefully evaluate the differences in the transparencies which are one stop underexposed and one stop overexposed in relation to the one determined to be the proper exposure.

EXERCISE I — SUPPLIES

- ❏ Camera and lens
- ❏ Tripod
- ❏ Model
- ❏ One roll of each specific film to be tested
- ❏ 18% gray card
- ❏ Light meter (incident or spot)
- ❏ Notebook

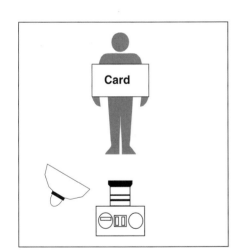

EXERCISE II — SUPPLIES

☐ Camera and lens

☐ Tripod

☐ Model

☐ Hand-held incident light meter

☐ Color temperature meter

☐ In-camera or hand-held reflective meter

☐ 8 x 10 gray, white, and black cards

☐ One roll of color slide film

EXERCISE II: REFLECTED AND INCIDENT LIGHT METERS

Objective: To examine the difference in the performance of reflective and incident light meters.

Supplies needed: Camera and lens, model, tripod, hand-held incident light meter, in-camera or hand-held reflective meter, 8 x 10 gray, white, and black cards, one roll of color slide film.

Instructions:

1. Place the model in a light source (Daylight will be easiest.) and have the model hold the gray card under his or her chin.

2. Place the camera on the tripod and fill the frame with the model's head and gray card.

3. Take a reading of the light falling on the gray card with the incident meter.

4. Make an exposure at the indicated reading.

5. Take a reflected light meter reading using the gray card.

6. Make another exposure using the indicated reading.

7. Repeat steps 3-6 using the black and white cards.

8. Have the film processed and examine the differences between the three series. Each of the three exposures made with the incident meter should be identical. Compare the skin tones in the three exposures made with the reflected light meter. You should see density differences in the skin tones and exposure because the readings were taken from different sources (white, gray, and black cards).

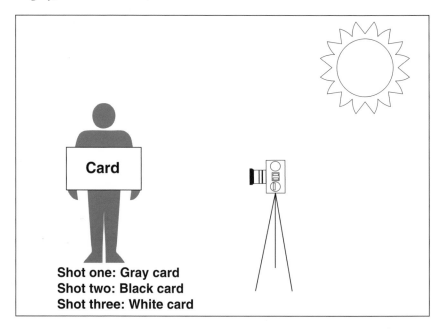

Shot one: Gray card
Shot two: Black card
Shot three: White card

EXERCISE III — SUPPLIES

☐ Light source (strobe or tungsten)
☐ Model
☐ Wall or back drop
☐ Incident light meter
☐ A large interior room with no daylight source

EXERCISE III: DEPTH OF LIGHT AND INVERSE SQUARE LAW

Objective: To examine depth of light and the inverse square law.

Supplies needed: Light source (strobe or tungsten), model, wall or back drop, incident light meter, a large interior room with no daylight source.

Instructions:

1. Position the model two feet in front of the light source with a wall or background ten feet behind. Make sure the light source is directed at the model and background.

2. Take a light reading at the model's nose and another at the background. Write down the difference.

3. Make an exposure.

4. Move the model two feet back, towards the wall so that he or she is four feet from the light source, and take another set of readings. Note the difference.

5. Make an exposure

6. Move the model four feet back and again take meter readings (The model will be eight feet from the light and two feet from the wall).

7. Make an exposure.

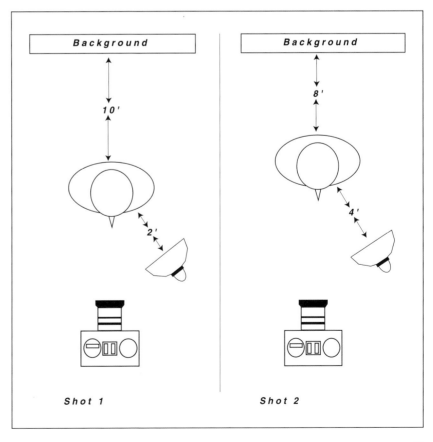

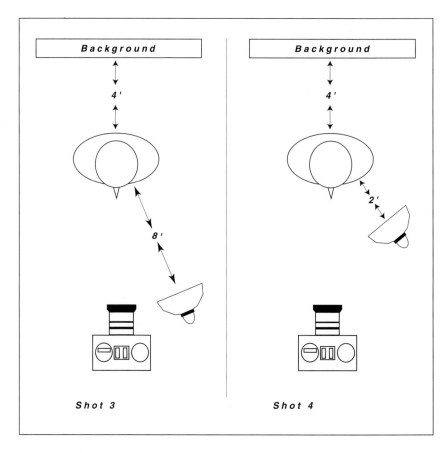

8. For the final series of readings and exposures, move the light source so it is two feet from the model (leaving the model two feet from the wall). Take the readings, and note the difference.

9. Make an exposure.

10. Have the film processed and examine the results. By comparing frames, you should see how the distance of the light source from the background affects the exposure on the background. You will also see how the relationship between the light/subject and subject/background changes as the model becomes farther from the light source and closer to the background.

CHAPTER THREE

Direction of Light

The third property of light is direction. Direction of light refers to the way the light strikes your subject or scene. Since light travels in a straight line, it is easy to visualize your photographic lighting coming from one particular direction and striking your subject.

Generally, we have total control over the placement of our electronic lighting. However, with a fixed light source such as the sun, we must often turn or move the subject to achieve the lighting direction desired. Side lighting will emphasize texture as it rakes across the subject. Frontal lighting will tend to flatten out subjects by removing shadows. Back lighting will create the primary shadows on your subject's face. Usually, the most flattering lighting for people photography is that which comes from the front of the subject, but off to one side. The direction of the light affects the appearance of the shape, form, and texture of the subject being photographed. Understanding how the direction of light can influence photography is summed up in understanding *CHIAROSCURO* ■.

Chiaroscuro is the arrangement of light and dark parts in a pictorial work of art; the light and shadow areas define shape. The concept of chiaroscuro was understood by master painters who sought to realistically represent three-dimensional subjects on two-dimensional canvas. Put simply, if a picture or photograph is too dark or too light, and/or has too little or too much detail, we may not see the image well.

When something is illuminated by light that is too soft, the lack of shadow leaves the subject without depth and form. Just as the human brain corrects slight changes in light's color temperature, our brain also adjusts to balance highlights and shadows. Shadows establish a sense of time by the way the light strikes the model. We get a sense of time by the length and direction of shadows. For example, early morning and late afternoon daylight will cast longer shadows than midday. In nature, direct light never comes from below a subject. For this reason, lighting a subject from below necessarily appears unnatural. "Fright light," a form of lighting from below used in early horror movies, was meant to make characters seem unnatural and evil. This unnatural light makes scary characters all the more convincing

• **What we see and think we see will not always end up on film.**

■ CHIAROSCURO

The relationship between the light and shadow in a scene

and disturbing. Except for creating special effects, this type of lighting is generally not used in people photography.

The Law of Reflection

The law of reflection states that light striking an object reflects off that object at the same angle. For example, light striking an object at a 45 degree angle reflects off that surface at a 45 degree angle. If a surface is rough, light will diffuse, scattering in different directions. Smooth surfaces do less to effect the bounce of the light.

When you try to photograph someone with a flash in front of a mirror, or window, the reflective quality of those surfaces can cause a problem. These surfaces can have a 95-99% reflective efficiency. If the light leaving your flash unit strikes the surface perpendicularly, it will reflect straight back into your lens. Since your subject probably only has an 18% (average) reflectance, the light reflecting from the mirror dominates the scene. The

"IF A SURFACE IS ROUGH, LIGHT WILL DIFFUSE..."

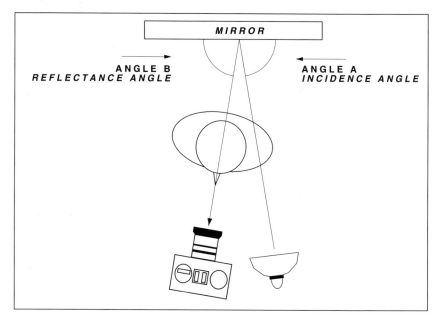

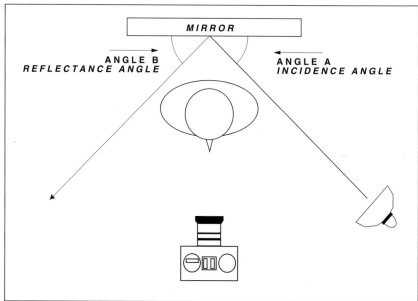

resulting photograph will show a predominant blob of flash light and will ruin the image.

Metal, mirrors, glass, and skin can be good reflectors when the light striking them has the right incident angle. If you must photograph in front of a mirror, glass or shiny metal wall, move your flash off camera to an angle which will reduce or eliminate the reflection.

Key Light

The term "key" or "main" light indicates the light which creates the dominant visible shadows on the subject. The key light will generally be from one source. It can be any source or any type light. The key light is not

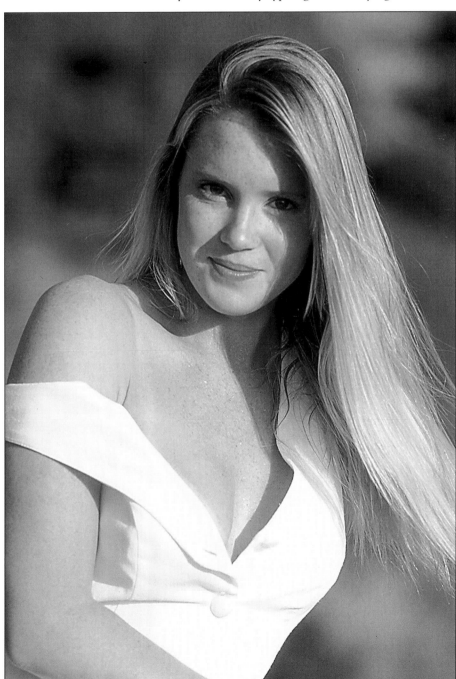

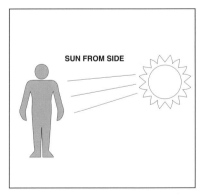

This model was photographed using direct natural daylight. The model's smooth skin can handle the direct lighting. A Canon EOS 1 and 300mm f/2.8L were used. Camera settings were 1/1000 sec. at f/2.8

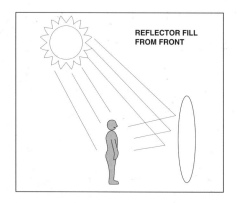

• **The fill light should create no shadows of its own.**

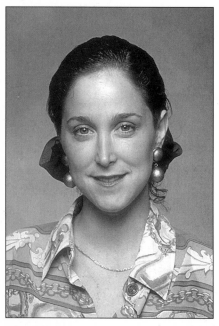

The fill light was placed in a large umbrella and positioned slightly left and above the camera. A Norman P2000 was used for the light source.

always placed in front of the subject. In cases where it is placed elsewhere, fill lights are used to bring out detail in shadow areas.

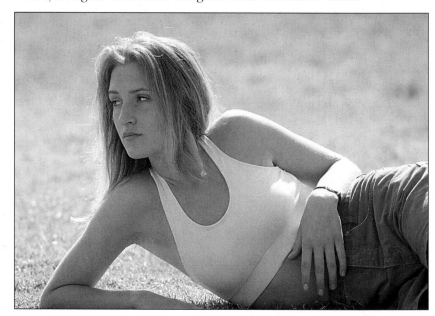

The key light, the sun, originates from behind the model. A white reflector was used to reflect light into the model's face to reduce total contrast.

To measure the proper intensity for the key light, hold an incident meter at the subject's position, and point it directly at the light source. To determine the proper exposure for the shadow area, meter as you would for total and local contrast

Fill Light

A fill light is any light which is used to bring out the detail in shadow areas. Fill lights reduce the contrast ratio of the scene by illuminating areas that would otherwise be underexposed. Contrast ratios must be controlled to allow proper detail not only on the film source, but for the printing medium as well.

A fill light is never more intense than the key light. By virtue of its assignment, fill light will be relatively large, soft, non-directional, and non-specular. The position of the fill light is critical because it should not cast shadows visible to the camera. Generally, the fill light is placed at or near camera position; however, if the key light comes from the side of a subject, the fill light may be placed to the opposite side.

Meter the fill light source with an incident light meter held at the subject position. Determine the intensity of the highlighted side by pointing the meter towards the light source. Once the key and fill intensities have been metered, an overall exposure reading should be taken by pointing the meter directly at the camera. Adjust the fill light as necessary.

Almost any light source, or combination of several light sources, can be used for fill light. Common sources of fill light are reflectors (i.e. — light-colored buildings), strobes, and sunlight.

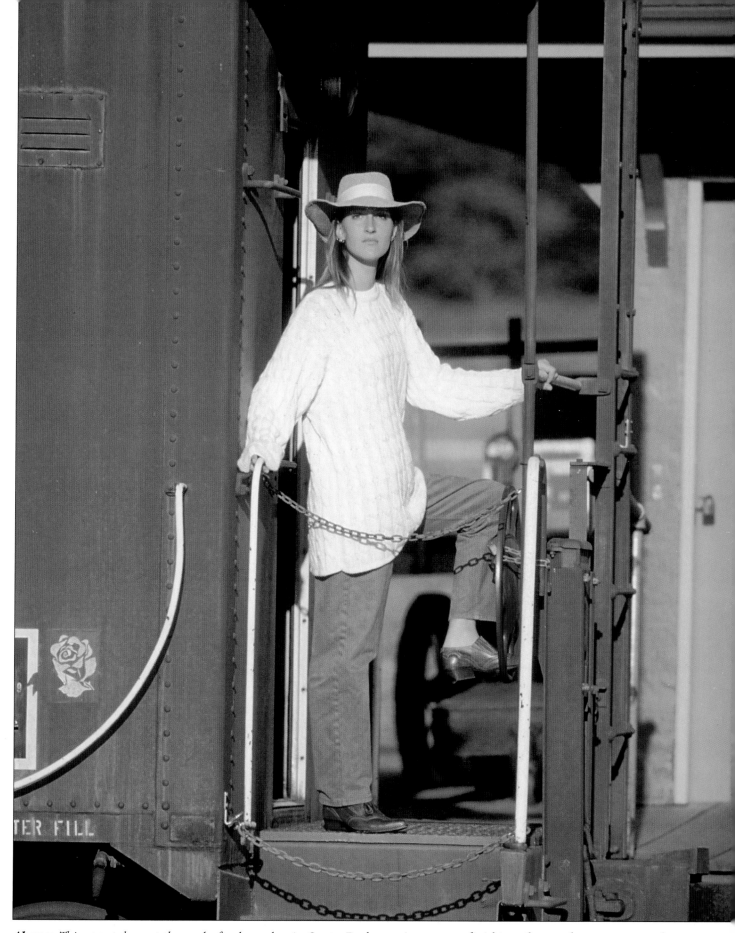

Above: *This was taken at the end of a long day in Santa Barbara. As we were finishing, the sun began to set and got extremely warm. I made this shot with a Canon 300mm f/2.8L lens wide open. An 81B filter was used to increase the already beautifully warm sunlight.*

Left: Three lights in my studio were used for this photograph. One light was used to light the background and the girl's hair. Two lights were used in front of the girl. The key light was placed in a large umbrella (44 inches) with a diffusion panel over the front. The fill light was a rectangular soft box, placed behind the camera to fill with 2/3 stop less light than the key light. Taken with a Hassleblad 500 ELX and a 150mm lens set to f/4.0.

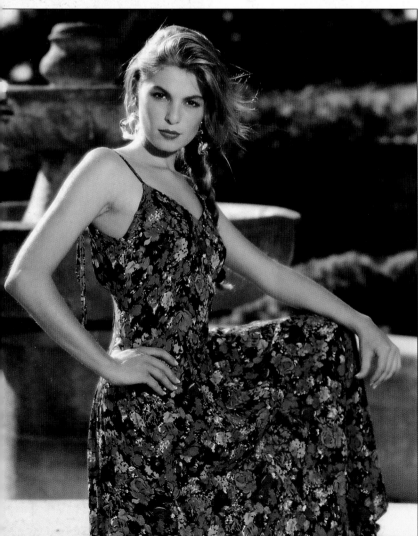

Left: Taken in the late afternoon, this shot uses the sun to key light the model from behind and a battery portable strobe was placed to camera right to brighten up the model's front.

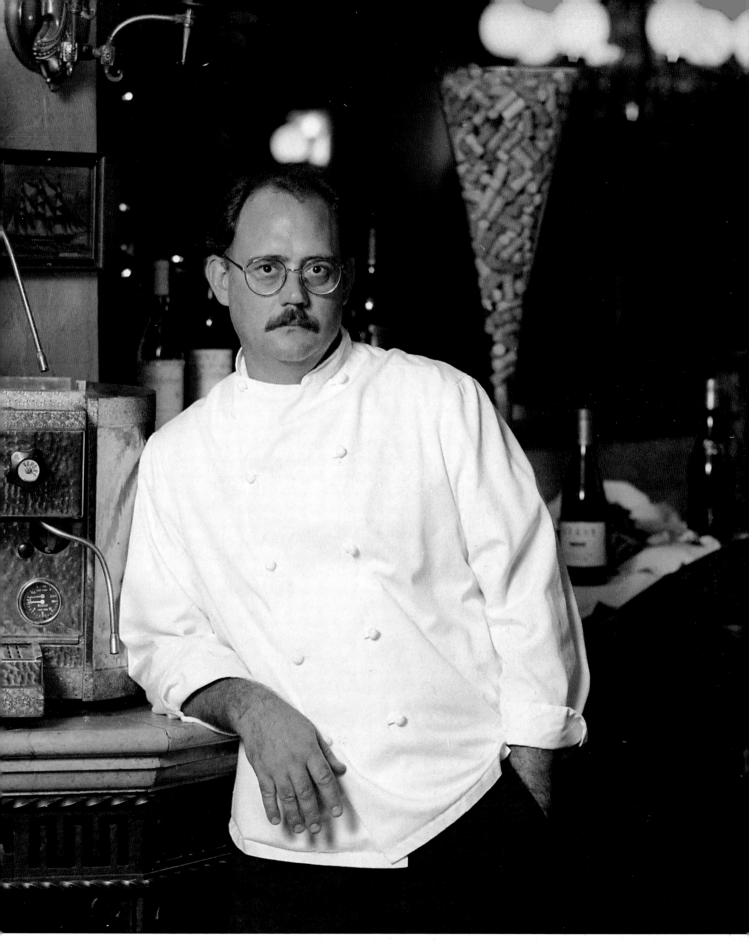

Above: *While photographing the top chefs in Denver, I used this great location at a downtown restaurant. The chef was lit with one battery portable strobe. The light was placed in a large covered umbrella approximately 10 feet from the chef. The light was large enough to illuminate the background slightly. Exposure was 1/250 sec at f/4.0.*

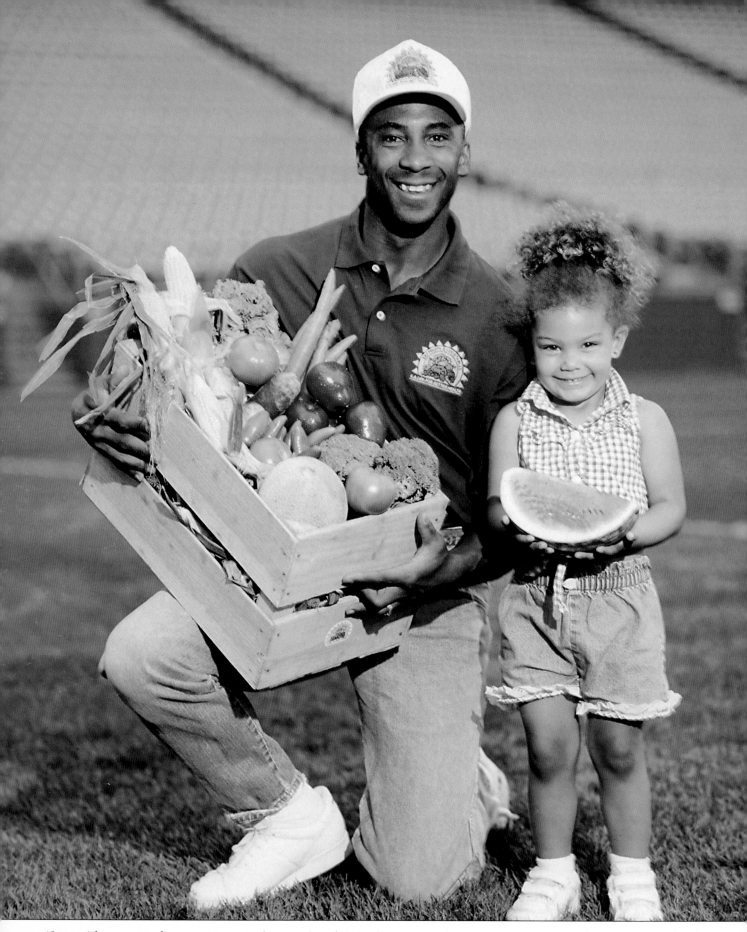

Above: *This image of NFL star Vance Johnson was taken at the Denver Broncos Stadium. After a commercial shoot, I had a few shots left on the roll of film, so I placed Vance's daughter next to her dad and shot. I used a Hassleblad 500c/m camera with a 150mm lens at f/5.6.*

Front Light

Front lighting is light which comes primarily from directly in front of the subject (0 to 45 degrees off-axis). Direct frontal lighting flattens the appearance of the subject because it does not cast shadows that are visible to the camera. Generally, use frontal lighting off-axis for best results.

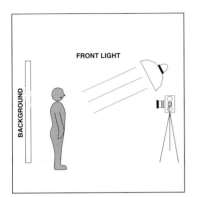

Left: Setup

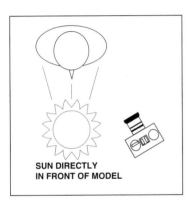

Right: Setup

The strobe was placed directly above and slightly to the right of the camera. This provides even, shadowless lighting on your model.

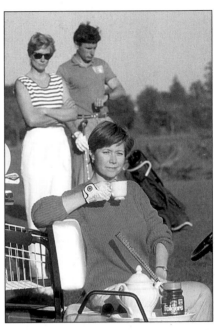

This product photo was taken with direct sunlight from the front. For a large set, this can provide even lighting over a wider area.

Side Light

Light striking the subject from 45 degrees to 90 degrees off-axis is considered to be side lighting. This type of lighting creates strong shadows. Side lighting can be very flattering and is a great tool for creating mood.

Rim Light

Rim lights (also back lights or kickers) come from behind the subject and help to separate it from the background. Rim lighting is usually adjusted to provide separation without dominating the image. Light intensity will be affected by the angle of incidence and the surface from which it reflects. Kicker lights can help to separate the model from the surroundings.

Metering for rim light is standard, but the angle of incidence will affect the appearance of the intensity. Because the light coming from behind a subject reflects with high efficiency, it may need to be adjusted. As a rule of thumb, back light should provide an intensity equal to or slightly less than the metered exposure value for the photograph. Also, do a polaroid test to ensure that brightness and separation are correct.

"...DO A POLAROID TEST TO ENSURE THAT BRIGHTNESS AND SEPARATION ARE CORRECT."

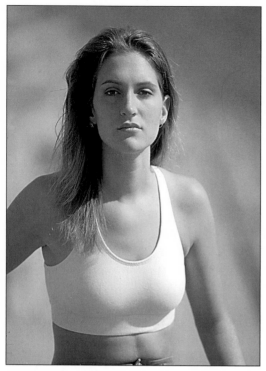

Side light originates from the side of the model and renders half of the subject in shadow if no fill light is used. This photo was taken late in the afternoon to get directional side light.

Rim light originates from behind the model and illuminates the back edge of the subject. Here exposure was set for the rim light with no frontal lighting.

Hair light is directed at the subject's hair to add life and shine. Care should be taken not to over light the hair. This results in hair without detail.

Background light separates the model from her environment. Background lighting also creates depth within a photo.

- **Hair lighting emphasizes hair texture, and provides separation between the subject and the background.**

- **Background light can add to the ambiance and depth to photographs.**

Hair Light

Hair light is back light which highlights the hair. The lighting used for hair lights varies. Some photography is enhanced by specular hard light, while softer lighting can add shine and specularity without creating hot spots.

Background Light

Traditionally, background light provides the highlight on studio portrait background canvases. They provide ambiance similar to mood lighting in restaurants and shopping malls.

In portraiture, background lights are placed behind the subject and directed at the background. A grid spot or snoot will allow you to place strobes farther away. If a bare bulb head is used, lights will need to be placed close to the background to create a hot spot. The hot spot is the highlight on the background. Due to the close proximity of the light to the background, there is rapid fall-off around the hot spot creating a bright area just behind the subject. This helps to separate the subject from the surroundings, while the rapid fall-off allows accent lights to do their job. It is might be necessary to adjust the light to about 1/2 stop brighter than the key light. The material and color of the background, however, will have a bearing on light reflectance.

Background lighting can be metered several ways. When using a sweep or seamless background, use a spot meter to measure the reflected light. Once the exposure value is determined for the subject, the value for the background can be set to create any effect the photographer desires.

If using an incident meter for the background, the reading will only indicate the light falling on the background and not the light reflected from the background. If the background is 18% gray, metering with an incident meter will result in accurate exposure. If it is more or less reflective than 18% gray, or colored, it will be difficult to judge the reflectance efficiency of the material. In this case, you can test the reflectance of the background material by taking a test shot with a polaroid camera. This will help you determine if more or less light is needed on the background.

Another solution would be to do an exposure test on the background. Set up the background light in the same position as you would for a portrait session. Adjust the light so that the incident meter reading of the hot spot is f/8.0. Now make a series of exposures of the background using slide film, starting at two stops underexposure by setting your camera at f/16. Bracket your exposures at half stop setting from f/11 through f/4.0. When you have the film processed, you will have nine exposures.

By studying these test results, you will know how your background will look exposed at the incident meter's reading and how you can control the appearance of the background by over or under exposing it.

When photographing without sweep or drop backgrounds, background lighting can be tricky. To light large set ups, use large umbrellas to provide ambient light. This technique allows you to evenly light an entire set and then bring in the key light at a slightly greater intensity. Another method is to use soft boxes. Control the background light so that it does not affect subject lighting.

"...BACKGROUND LIGHTING CAN BE TRICKY."

Meter background light values for large sets with an incident meter. The brightness level will vary, but generally the background should not overpower or distract the viewer's attention from the subject. A background lit to 1/2 stop less than the main subject will usually give good results. The placement of a background light will vary with the type of equipment being used.

Lens Flare

• **Lens flare is caused by source light directly striking the front element of a lens. Flare decreases contrast and desaturates colors.**

Any time light comes from anywhere other than the camera position, photographers must be aware of the potential for lens flare. When light comes from in front of the camera, the chance for lens flare increases. Internal lens flare exists in every lens, although it is less prevalent in higher-priced lenses

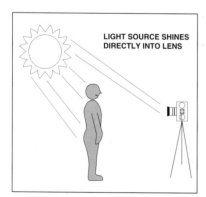

Lens flare creates reflections inside the lens. It increases contrast and degrading the entire image.

LIGHT SOURCE SHINES
DIRECTLY INTO LENS

By placing a flag between the lens and light source, lens flare can be controlled. Compare to photo on the opposite page.

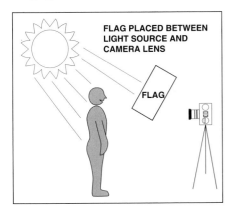

FLAG PLACED BETWEEN
LIGHT SOURCE AND
CAMERA LENS

FLAG

■ REMBRANDT LIGHTING

Lighting style in which the key light creates a drop shadow from the nose which falls on the subject's cheek and merges with the shadows on the unlit side of the face.

This lighting style used by the artist Rembrandt divides the subject's face in two giving it shape and depth.

because of extra coatings and internal linings. The most important objective is to make sure lens flare is minimized.

To minimize lens flare there are several safeguards. One is to always use the lens hood designed for the lens being used. After-market lens hoods, not manufactured for a specific lens, are designed to fit lenses of varying focal lengths but are often inefficient.

A second precaution to take is to ensure that no stray light is directed into the lens. First, place the camera on your tripod, and put your lights into position.

Once everything is in place, walk to the front of the camera and look into the lens. If you see any reflections on the surface of the lens, you are losing image quality from flare. Correct this by placing flags between a light source and the camera lens.

If possible, redirect the light so that it does not reflect into the lens. An 8" x 10" black card, your hand, or moving the camera position can also protect your lens from flare.

Lighting Patterns

Lighting patterns are standardized positioning of the key and fill lights. One of the most common lighting patterns in portraiture is *loop lighting*. In this positioning the key light is placed to the side of the model's face, about 25 degrees left or right of the subject's nose. The light should be positioned slightly higher than the model's head.

Another very popular lighting pattern is REMBRANDT LIGHTING ■. This pattern lights the subject's face from about forty-five degrees to one side and creates strong shadows. Using this pattern divides the face into two sides and gives shape and depth to the model's features.

Broad and *short* lighting are two approaches to Rembrandt lighting which can change the appearance of a subject's face. *Broad lighting* is used for a subject whose face is narrow and long. Turn the subject's face slightly to one side (so that one ear is not visible to the camera). Place the key light beside the camera so that it illuminates the side of the subject's face that is towards the lens. This will result in the face appearing wider than it really is.

Short lighting is used for a subject who has a wide face or when a narrowing of the facial features is desired. With the face turned slightly away from the camera, the key light is placed on the side of the face farthest from the camera. This type of lighting results in the face taking on a narrower appearance than it would otherwise.

Paramount (or butterfly) lighting is named for the film studio that used the pattern. The key light originates from camera position and casts a shadow directly below the nose. This light pattern is seen primarily with female portraiture, but not exclusively so. The brightest area of the photograph will be between the model's eyes, and the face will be evenly lit.

With loop lighting, the shadow created by the nose falls just above the corner of the subject's mouth.

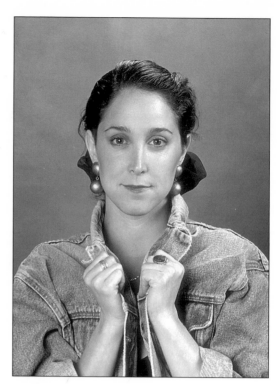

Rembrandt Lighting (or Closed Loop). Note the angle of the shadow created by the subject's nose.

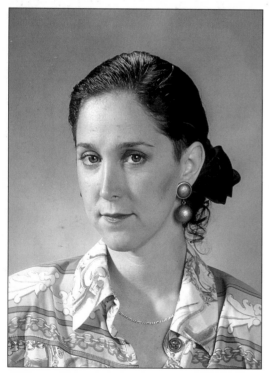

Short lighting originates on the side of the model's face that is away from the camera. Here the short side of the face is on the left side of the photo.

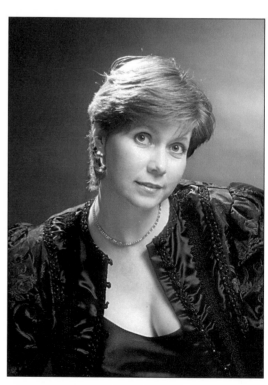

Butterfly or Paramount lighting. The light originates above the model and casts its only shadow between the tip of the subject's nose and the top edge of the lip.

In split lighting, the key light comes at the subject from the side. The subject is "split" by the key and fill light. If the Key/Fill ratio is 1:1, the lighting appears flat and will look like direct frontal lighting. It is more common to see split lighting with ratios of 1:2, 1:3, or 1:4.

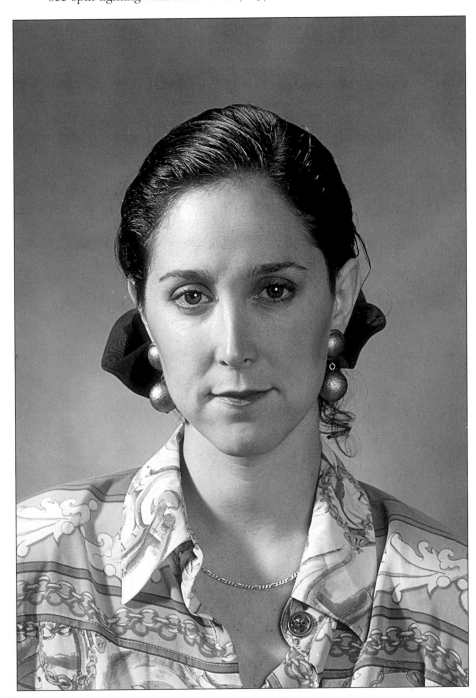

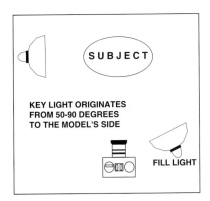

With split lighting the key light originates from 90 degrees off the lens/subject axis dividing the subject's face into two equal parts. Here the lighting ratio is 1:3.

Chapter Three Exercises

EXERCISE I: EFFECTS OF DIRECTIONAL LIGHTING

Objective: To examine the effects of front light, side light, back light, and fill light.

Supplies needed: Camera and lens, tripod, model, one roll of slide film, light meter, 2 fill cards (at least 16" x 20") or reflectors.

Instructions:

NOTE: In this exercise, you can use daylight or flash. If you use daylight, you will have to turn your subject around in order to get the direction of light you desire. If you use strobe/flash, you can keep your subject stationary, and move the lights for directional control. For this entire exercise, keep your subject looking into the camera for full-face exposures. Place your camera at or slightly above your subject's head height, and have your light slightly higher than your camera. If you are using the sun, a good time to do this exercise will be between nine and eleven in the morning, or between three and five in the afternoon.

1. To examine the effects of front light, position your subject so that the light is directly in front of him or her. You will have the light behind you, and your subject will be frontally lit.

2. Meter the light for the incident value at the subject's nose, and make a series of exposures for this lighting arrangement.

3. For side light, move the light (or, if outside, your subject) so the light strikes the model directly from one side.

4. Meter your light at the subject's cheek or nose on the lighted side of the face with the diffusion dome of your meter facing the light. Make a series of exposures with this lighting arrangement.

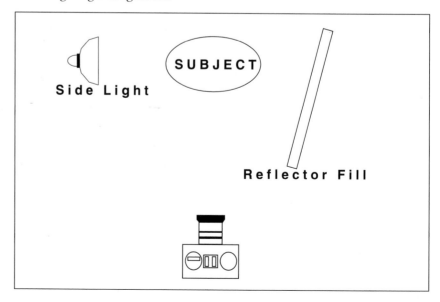

EXERCISE I — SUPPLIES

❏ Camera and lens
❏ Tripod
❏ Model
❏ One roll of slide film
❏ Light meter
❏ 2 fill cards or reflectors

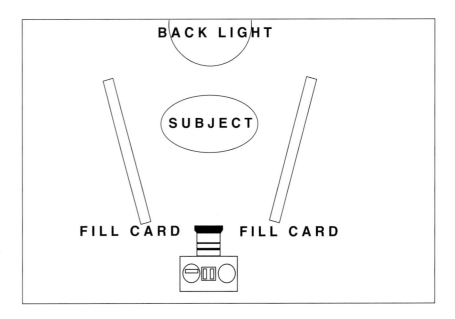

5. For back light, move your subject or light so that your light strikes the model directly from behind. This will place your subject's face in shadow.

6. Meter the exposure for the subject's face. This way you will see the back light in the final photo. Make a series of exposures for this lighting arrangement.

7. Repeat steps 3 and 4 above, but use a reflector card to fill the shadow side of the subject's face. Place the fill card about two feet from the model opposite the key light. (See left diagram.)

8. Repeat steps 5 and 6 above, but now fill the model's face with two fill cards by placing the cards at 45 degree angles to the subject. The cards should be placed about two feet from the model's face. Make a series of exposures with both cards and another with only one card. (See diagram.)

9. Have the film processed and evaluate the results. Look at the changes in the appearance of the shape of the model and the changes in the texture of the clothing or skin. Note the change in mood.

EXERCISE II — SUPPLIES

❒ Camera and lens
❒ Tripod
❒ Model
❒ One roll of slide film
❒ Flash meter
❒ Fill flash

EXERCISE II: ANGLE OF INCIDENCE

Objective: To evaluate the effect of a light source's angle of incidence.

Supplies needed: Camera and lens, tripod, model, one roll of slide film, flash meter, fill flash.

Instructions:

1. Place your model so that he or she is illuminated by front light.

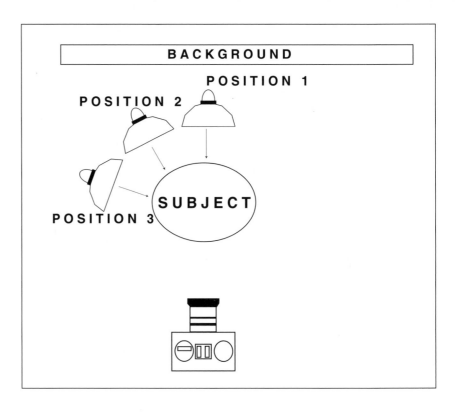

2. Place the back light so that it is at position one in the diagram (see above) and set the intensity of the light so it is 1/2 stop more intense than the key light. Take a series of exposures.

3. Move the back light to position two, and then position three, and make a series of exposures at each position. The intensity of the flash and the distance to the subject should remain the same throughout this exercise. Be sure that no stray back light enters the lens.

4. Place the back light above the subject and direct it downward so that light passing the subject will hit the ground. Set-up is easier if you use a lens which allows placement of the camera ten or more feet from the subject.

5. Have the film processed and examine the difference in the appearance of the back light in each of the positions. Note the changes in the brightness of the back light.

EXERCISE III — SUPPLIES

❏ Camera and lens
❏ Tripod
❏ Model
❏ One roll of slide film
❏ 2 strobes or hot lights
❏ Light meter

EXERCISE III: DIFFERENCES IN LIGHTING PATTERNS

Objective: To examine the difference between butterfly, Rembrandt, broad, and short lighting patterns.

Supplies needed: Camera and lens, tripod, model, one roll of slide film, 2 strobes or hot lights, light meter.

Instructions:

1. Place the model in a comfortable position indoors.

2. Set the camera at the same height as the model.

3. Place a light one to two feet directly above the camera.

4. Adjust the light so that the nose shadow falls midway between the model's nose and the top of her upper lip.

5. Meter the light and make a series of exposures of this set up. Take the series with no fill light.

6. Place a fill light next to or behind the camera, at camera height, and adjust the intensity so that it is 1/2 stop less intense than the key light.

7. Meter the total intensity and make a series of exposures.

8. For this third series of exposures, move the key light so that it creates the Rembrandt pattern. (See page 45.)

9. Make a series of exposures without a fill light.

10. Adjust a fill to provide 1/2 stop less than the key light.

11. Make a series of exposures using the fill and key light.

12. Now turn the model's head left or right so that one ear is not visible to the camera. Have the model look to the camera.

13. Place the key light to either side of the camera so that it illuminates the side of the model's face closest to the camera (broad lighting) in the Rembrandt pattern.

14. Using only a key light, make a series of exposures.

15. Add a fill light adjusted to provide 1/2 stop less light than the key light, and make a series of exposures.

16. Finally, turn the model to the opposite side and adjust the lighting so that Rembrandt lighting occurs from the short side of the face (short lighting).

17. Make two series of exposures, with and without a fill light.

18. Have the film processed and evaluate the differences in the results of each lighting set up. If two models are available, one with an oval face and another with a slender face, shoot this exercise with both models, and compare and contrast the effects the lighting has on each.

CHAPTER FOUR

Quality of Light

The fourth property of light is quality. A subject takes shape and form by the way light strikes it. Light quality ranges from hard and contrasty to soft and diffused. For example, an on-camera flash generally produces hard, contrasty light. Soft, diffuse light is obtained from a large soft box. Knowing how to use hard and soft light sources will help you control subject shape.

Translucent Diffusion

Light can be diffused with a *TRANSLUCENT DIFFUSION* ■ panel or silk. These light modifiers soften light and reduce contrast. They can be commercially made or homemade using bed sheets. After diffusing the light, the brightness level of the subject can be controlled without having to fill the deep shadows which would exist in harder lighting.

During use, the diffusion panel is suspended between the light source and the subject. The panel can be held with a stand, or it can be held in place by a sturdy assistant. It is Murphy's Law that whenever a diffusion panel must be employed, the wind will blow. Even when using stands, always have an assistant (or two) to help secure the panels.

Diffusion panels can be any size. The television and film industry often use silks as large as houses. A larger diffusion panel provides the luxury of being able to move models around beneath the panel without having to move the panel itself.

Scrims, Gobos & Subtractive Lighting

At times a photographer will want to decrease or eliminate light striking a model from an undesirable direction. In these times, a flag or a scrim can be used to block all or part of the light striking the model. Scrims come with varying light-blocking abilities and are sold in a variety of densities.

Gobos (also called flags, or cutters) are used between a light source and the camera or subject to block light spilling into unwanted areas. Flags are generally made of black felt or velvet-like fabric stretched over a metal frame for rigidity. When used for blocking light from striking the camera

■ TRANSLUCENT DIFFUSION

A diffusion panel which transmits and softens light.

"...A FLAG OR A SCRIM CAN BE USED TO BLOCK ALL OR PART OF THE LIGHT..."

• **Anytime a strobe or light modifier is used on a stand, it is important to weight the stand down with sand bags.**

This shot was made using natural light and a reflector. The overhead natural light was softened with the diffusion panel placed in front of the model. A Bronica ETRS and 80mm lens was used with a camera setting of 1/250 sec. at f/2.8.

lens, they are usually called flags or cutters. When used for blocking light from striking a model they are larger and called gobos. Whatever the name, the purpose is the same. Flags are suspended on stands, out of the way and as close to the model as possible.

Subtractive lighting can help separate the subject from the environment. It is essentially the opposite of back lighting for separation. A dark flag or gobo is used to absorb light which would otherwise reflect onto a subject. Subtractive sources darken a portion (usually an edge) of a model to separate it from a brighter background.

Bounce Lighting, Reflectors, and Mirrors

Bounce lighting, reflectors and mirrors can add highlights or exposure to a subject. Reflectors can be rigid or flexible, large or small, colored (gold, silver), or white and can produce hard or diffuse light. Whatever the makeup of a reflector, its purpose is simple: reflect light back into a scene. If a reflector produces hard light, its primary use may be for separation lighting; if it is soft, it will be used best as fill lighting. A reflector will always be a secondary light source and consequently will be relegated to use as a fill or kicker light.

The above diagram illustrates how a gobo is used between a light source and subject to block light spilling into unwanted areas.

Mirrors are used to bounce light into a photograph and are usually used as kicker sources because of their efficiency and specularity. They are extremely efficient and can reflect up to 99 per cent of the light striking them. Because of a mirror's silver backing, the light bounced from a mirror will be quite hard and works well for back lighting.

Soft Light

Soft light is less directional than hard light and is generally much more suitable for people photography. The omnidirectional nature of soft light helps lighten shadows, and flatters the skin by seemingly reducing wrinkles, blemishes, and bumps.

Highlight-to-shadow contrast is lower than hard light, and it is easier to get detailing. Soft light can be obtained by diffusing source light with silks or scrims, or using reflective diffusers like large photographic umbrellas. Sunlight on an overcast day is considered soft light.

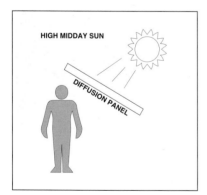

A hand held white diffusion panel was used between the model and the sun to provide soft, shadowed lighting. Note the soft contrast in the eye sockets and beneath the chin on the subject's neck. Compare with the photo on next page.

Hard Light

Hard light can be identified by a high contrast. The harder the light source, the more sharply defined the contrast. Hard lighting comes directly from the source and results when the light source is small in relation to the size of the subject. Unobstructed sunlight, such as midday with little or no cloud cover, also produces very hard light. When using unmodified hard light, only the highlight or the shadow area of a photograph can be correctly exposed. The over or under exposed parts of the scene will have a lack of detail. Most film will not be able to handle the high contrast ratio. This light is generally unacceptable for people photography

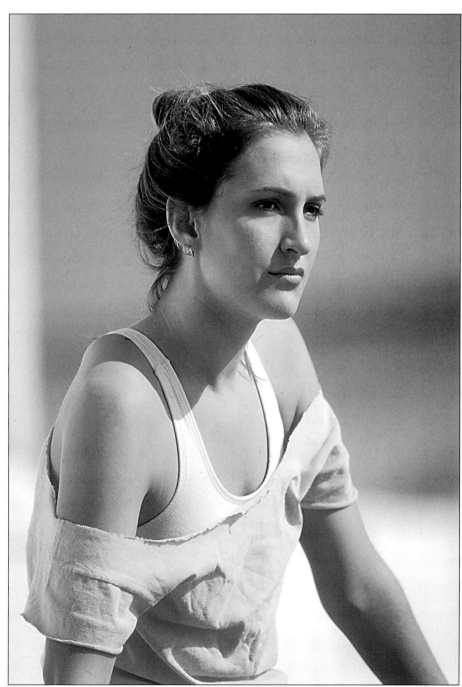

HIGH MIDDAY SUN

Direct sunlight can create deep shadows around the model's eyes and below her chin.

Specular Light

Specular light is a type of hard light that comes from highly reflective light sources. For example, the light reflecting from a mirror or silvered reflector is specular. A specular light source will be evident by the telltale highlights it produces. For general photography, specular light can help to accentuate shape and form for some subjects, but for people photography, a softer light is generally preferred.

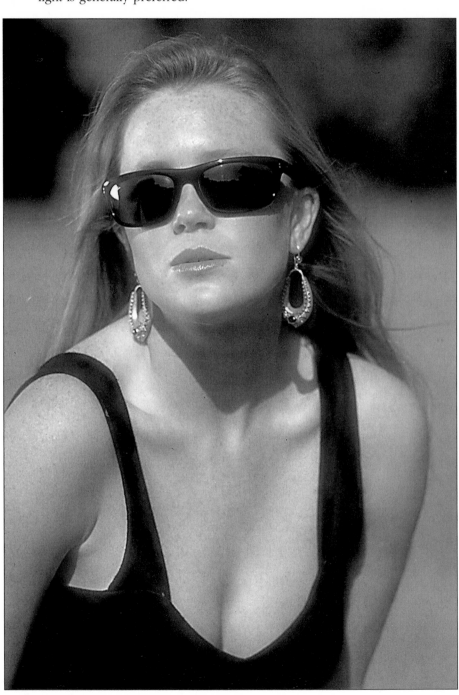

Direct specular light (here from the sun) can cause specular highlights especially when the model's face is a little oily. This can be helped by powdering the model or softening the light.

Softening Hard Light

Hard light should be modified for use in people photography. To make hard light sources softer, increase the effective size of the source. The effective size increase is accomplished by bouncing, diffusing, and/or reflecting the light. The greater the increase, the softer the light becomes.

To modify light use a gobo, silk, soft box, umbrella or a simple white bed sheet as a diffuser. The source light will be modified to a softer light if the gobo or other modifying agent is placed at a distance from the subject which is equal to the length of its longest side. For example, if you are using a five foot by four foot bed sheet, place it five feet from the subject. When using diffusers, correct for color shifts.

Softening Strobes & Hot Lights

To soften strobes or hot lights, similar techniques may be applied. The options for studio lights are more numerous which is why many photographers prefer to work in a studio.

One way to increase the effective size of strobe light is to bounce the light off of a reflector, wall, or ceiling. If the ceiling or wall is too far from the subject, or of the wrong color or texture, another surface should be substituted.

One popular source for bouncing light is white foam core. This is available in eight foot by four foot sheets. Two sheets can be attached to form a large 'V'. A foam core 'V' is portable, light-weight, and has many uses.

Another way to soften strobe or hot lights is to place diffusion material between the source and the subject. Materials with suitable color balance can be used as diffusion panels (silk parachute material, bed sheets, or frosted shower curtains). Soft boxes were designed to soften the natural harshness of strobe tubes.

Today some soft boxes are designed to allow the escape of the great heat created by hot lights. Soft boxes, which come in a wide array of sizes, are generally opaque on the sides with a diffusion panel at the front. Strobe heads are mounted inside. The reflective surface is usually white but can be silver or gold. Metallic lining alters color temperature, efficiency, and specularity.

Photographic umbrellas, like soft boxes, come in a wide array of sizes, shapes, and colors to allow for control of softness, specularity, and color temperature. Photographic umbrellas are less expensive than soft boxes and require less time to set up. They are also more directional than soft boxes. Many photographers use diffusion panels attached to the open side of their umbrellas. This allows the cost benefits of umbrellas while producing the softness of boxes.

The main differences between umbrellas and soft boxes are the shape of the catch light and the size of the units. Catch light is a specular highlight in the eyes of your subject. It appears as a mirror image of the light source being used — it is round when using umbrellas and rectangular when using soft boxes. Soft boxes are available in much larger sizes than umbrellas.

"Hard light should be modified for use in people photography."

• **It is important to test the transmission properties and color balance prior to any important shoot.**

"Catch light is a specular highlight in the eyes of your subject."

The exposure extremes of highlight and shadow of the main subject in a scene.

■ TOTAL CONTRAST

The exposure extremes of highlight and shadow within an entire scene.

Lighting for Contrast

Contrast, simply put, is the difference between extremes. In photography, this will be the difference, or ratio, between highlights and shadows in a scene. The higher the ratio, the greater the difference between the highlight and shadow areas. A 1:1 ratio indicates that the highlight and shadow areas of the photograph or subject are balanced. The ratio doubles as the difference between highlight and shadow increases by one stop. A 2:1 ratio indicates a difference of one stop, while a 4:1 ratio indicates a 2 stop difference. A ratio of more than 4:1 (2 stops) will result in decreased detail.

When planning lighting, it is important to plan for both the local and total contrast. LOCAL CONTRAST ■ concerns the contrast of a subject only. If there is too little contrast, the model may appear one-dimensional and formless; if the contrast is too severe, there will be a loss of detail. TOTAL CONTRAST ■ is the relationship between the main subject and the subject's environment.

Left: Setup

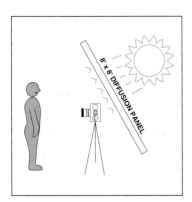

Right: Setup

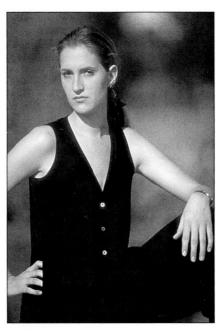

This is an example of high total contrast. Note the difference between the subject and the background. This photograph was taken under the branches of a tree used for diffusion.

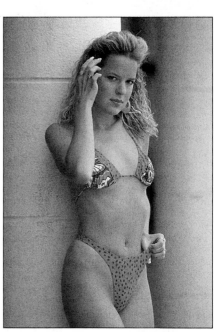

Here the model was placed in an atmosphere where the tonal range was less thus reducing total contrast.

It is important to know the mood you are trying to create before lighting the set up.

For example, a glamour photograph should have a very soft, non directional, low contrast light. Lighting used for contemporary fashion advertisements has very strong local and total contrast.

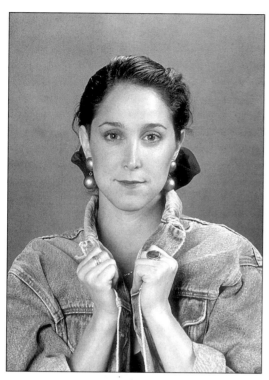

Lighting ratio of 1:1. The key light and fill light are equal. Both sides of the model's face receive the same light intensity.

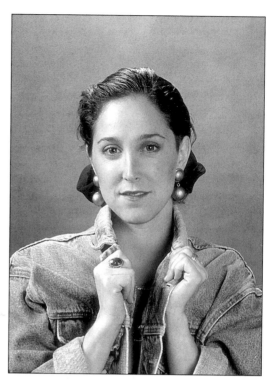

Lighting ratio of 2:1. The key light is one stop brighter than the fill light. The highlight side of the model's face receives one stop more light than the shadow side.

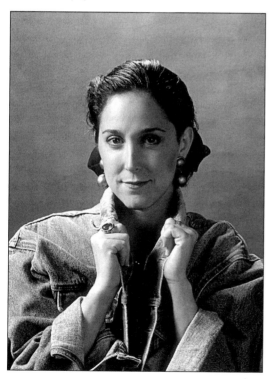

The lighting ratio is 6:1. The highlight value is 2.5 stops higher than the shadow value. The highlight side of the model's face receives 2.5 stops more light than the shadow side.

Glamour lighting was used for this photo. Very large umbrellas provided very soft lighting. A very close ratio between the key and fill lights create almost shadowless light.

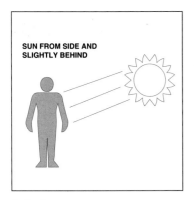

Left: Setup

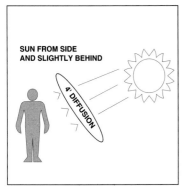

Right: Setup

Local contrast can be controlled by adjusting the light striking the subject. This can be achieved by changing the intensity of the fill or key lighting. Alter whichever light is easier to change.

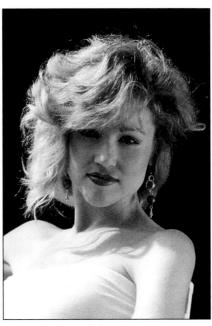

Note the high local contrast between the model's face (in partial shadow) and the model's body (receiving direct daylight).

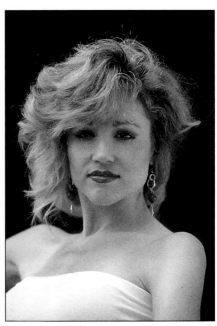

A diffusion panel placed between the model and light source evens out the lighting and reduces local contrast.

• **The best lighting for people photography is directional, soft lighting. This gives you the definition and contrast of hard light and full detail of soft lighting.**

Before controlling total contrast, the photographer should decide how he or she would like the main subject to record against the background. Once this has been determined, the illumination on the main subject can be altered in relation to the background. Generally the photographer will control the subject lighting for outdoor shots or control the intensity of the background light when in the studio. Control the lighting using the same techniques as when adjusting local contrast.

At times, more or less contrast will be preferred to set a mood. There is really no general rule for determining local contrast. For traditional portraiture, contrast ratios of 2:1, 3:1 or 4:1 are typical. For more contemporary portraiture they may be 8:1 (3 stop difference) or higher. For commercial advertising the range is typically as diverse as in portraiture, but in glamour photography, ratios will be closer to 2:1 or less.

Chapter Four Exercises

EXERCISE I: HARD AND SOFT LIGHT

Objective: To observe the differences between hard and soft light.

Supplies needed: Camera and lens, tripod, model, one roll of slide film, reflector card (4 x 8 white foam core or commercial reflector), light meter. This exercise can be done with strobe light, natural light, or both if desired. If a strobe unit is used, a flash meter is necessary.

Instructions:

Part One

1. Set up the camera on a tripod indoors.

2. Place a strobe unit three to four feet to the left and two feet higher than the camera. Use a reflector in front of the strobe or place near a white wall.

3. Place the model in front of the camera. (Sitting will be easiest for this exercise.)

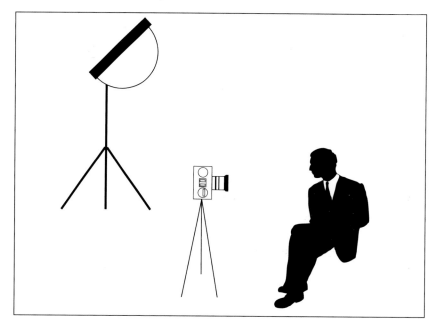

4. Point the unmodified strobe directly at the subject.

5. Make a series of exposures of the subject illuminated by the single strobe, ranging from 1 stop under to one stop over-exposure.

6. Turn the strobe around 180 degrees, and point it away from the model.

7. Place the reflector/bounce board about one foot away from the strobe head so that the light striking the reflector will bounce back onto the subject. If using a wall for a reflector, point the strobe at the wall.

EXERCISE I — SUPPLIES

❏ Camera and lens
❏ Tripod
❏ Model
❏ One roll of slide film
❏ Reflector card
❏ Light meter

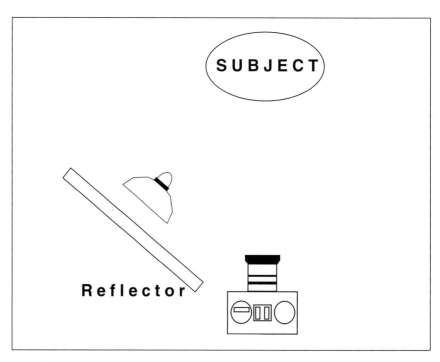

8. Adjust strobe power so that the lens aperture remains as close to the first photo series as possible. This step will keep depth of field the same, making it easier to evaluate and compare the two series.

9. Make a series of photos as in step 5.

Part Two

1. Place the model facing into direct sunlight, around 10 a.m, outside. Be sure that the daylight is striking the model so that there are visible shadows on the face.

2. Set up your camera about three feet in front of the model.

3. Meter the diffuse highlights, and set your camera for appropriate exposure.

4. Make a series of exposures of the model.

5. Turn the model so that the sun is directly behind him or her.

6. Place the reflector near the camera, level with the model's head, to reflect sunlight back to the model's face. Meter for the intensity of the light, and adjust the camera's controls for an exposure setting which keeps the same aperture that you used in part one of this exercise. The intensity of the light will vary here, dependent upon the surface quality of the reflector you are using.

7. Make a series of exposures of the model.

8. Have the film processed, and evaluate the difference. Pay special attention to the highlight/shadow transfer. This is the transition line between the diffused highlight value and the shadow exposure value for your subject. As the light gets softer, the transfer will become less abrupt. Once you have seen and evaluated the difference between the two techniques, you can make note of the results for future reference.

EXERCISE II: CONTROL AND EVALUATE LOCAL CONTRAST

Objective: To control and evaluate local contrast using a reflector as a fill light.

Supplies needed: Camera and lens, tripod, model, one roll of slide film, reflected light meter, 18% gray card, reflector/ fill panel.

Instructions:

1. Place the model so that sunlight strikes him or her directly from one side.

2. Using a reflected light meter, measure the light intensity on the highlight and shadow side of the model's face. Record the readings to aid with final evaluations later.

3. Using the exposure value for the highlights, make a series of exposures of the model.

4. Using the same set up, place a reflector panel 4 feet from the model on the shadow side of the model's face. The highlight side intensity stays the same, while the shadow side increases in value, decreasing the local contrast.

5. Take a light reading of the shadow side of the model's face, and record the reading.

6. Make another series of exposures of the model.

7. Have the film processed, and evaluate the difference in the local contrast between the unmodified lighting arrangement and the reflector-filled set up. Specifically, note the detail in the shadow side of the model's face, both without and with the fill reflector.

EXERCISE II — SUPPLIES

❏ Camera and lens
❏ Tripod
❏ Model
❏ One roll of slide film
❏ Reflected light meter
❏ 18% gray card
❏ Reflector/fill panel

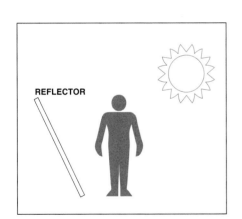

REFLECTOR

EXERCISE III — SUPPLIES

- ❏ Camera and lens
- ❏ Tripod
- ❏ Model
- ❏ One roll of slide film
- ❏ Strobe unit
- ❏ Flash meter

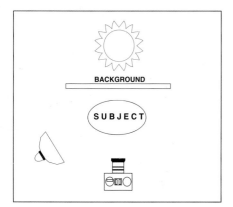

EXERCISE III: CONTROLLING TOTAL CONTRAST

Objective: To control total contrast through the use of strobe fill lighting.

Supplies needed: Camera and lens, tripod, model, one roll of color slide film, strobe unit, flash meter.

Instructions:

1. Place the model so he or she is lit with direct sunlight from behind. Use a background that is not very light or dark toned. This will aid in evaluating the change in total contrast.

2. Take a light reading of the subject's face and the background. Make a note of these exposure values.

3. Make a series of exposures using settings to properly expose the subject's face.

4. Using the same set up, place a strobe unit so it lights the subject from the front. Adjust the output of the strobe to deliver one stop less exposure than the background.

5. Adjust camera settings to overexpose the background by one stop.

6. Make a series of exposures.

7. Adjust the strobe fill to light the subject with an equal exposure value to the background, and expose for the background.

8. Make a series of exposures.

9. Finally, adjust the strobe fill one stop higher than the background, and underexpose the background by one stop.

10. Have the film processed, and examine the total contrast between the model and background. Compare the contrast change between the four series of exposures. These photos will help demonstrate that many exposure and contrast differences come down to preference and application rather than a measurable right or wrong.

SECTION 2

There are many ways the properties of light (color temperature, intensity, direction, and quality) can be controlled. The following section covers how to control lighting for people photography.

CHAPTER FIVE

Controlling Strobe Lighting

Strobe lighting systems used for photography are usually color balanced for 5,500 degrees Kelvin. This will vary with the age of the flash, replacement parts and the manufacturer. Test the strobe units using a color temperature meter to establish the true color temperature. Gel the strobe head to the temperature desired.

Another way to test is to photograph a test chart (such as The Macbeth ColorChecker Color Rendition Chart) using your light source and a film stock out of which you have already tested the color balance. Compare the processed slides with the color chart using a quality color balanced light box to see if there is any shift.

Strobe output ratings

To determine the power output of a particular strobe unit, use a flash meter. Battery powered units are rated by Guide Number (GN), while electric flash units are given watt-second ratings.

The Guide Number of a strobe is determined by metering the intensity of the strobe's output ten feet from the strobe with your meter set at ISO 100. Once you have measured the output of the strobe, multiply the reading by 10 to get the Guide Number.

**[GN ÷ flash-subject distance = intensity]
or [GN = flash-subject distance x intensity]**

For example, if the metered value of the strobe is f/11.0 at 10 feet, then the GN for the flash unit is 110. It is important to understand this procedure because you should test your equipment when you buy it (new or used) to know for certain how your equipment is performing.

By knowing the GN of your equipment, you can usually achieve a good to perfect exposure even when you don't have a flash meter with you. Remember the inverse square law, which states if you move your subject twice as far away from the light source (2x) you have an exposure decrease of 1/4 or two f/stops. For example, if you know the Guide Number of your strobe is 110, then you know that at ISO 100 and at ten

On-camera flash.

When a shutter speed is used which is greater than the flash synchronization speed of the camera, uneven exposure will result.

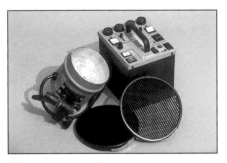

Electronic studio strobe equipment varies in size and output. This Dyna Lite is among the smallest on the market for its output.

Battery-powered portable strobe equipment can have the battery contained within the strobe head or connected to the strobe by a cable as it is in this unit.

feet, you have an exposure of f/11.0. Or if you wanted an exposure of f/5.6, you would need to move your strobe 19 1/2 feet away (GN 110 ÷ f/5.6 = 19.6 feet).

You can also adapt the information for use with other film types. For example, when using ISO 25 film you know that your film is two stops slower than ISO 100. If the calculated intensity is f/11.0, you will need to adjust two stops for the slower film. At a distance of ten feet, you would then have an exposure of f/5.6.

You can divide the GN by any flash-to-subject distance to determine the correct exposure. For example, if you have a GN of 120 and a flash-to-subject distance of 11 feet, you have an exposure of 10.9 or an f-stop of f/11. You already know how to determine your exposure using a different film type. Any aperture can be achieved by adjusting your flash-to-subject distance, adjusting the power output of your flash, or a combination of the two.

A watt-second rating is an indication of the power required to operate a power pack at full capacity. It is most important to know that by doubling or halving the output power of the power pack, the resulting change in the output will be one f-stop. However, factory provided power ratings are not always accurate. This occurs due to a lack of standardized testing. Consequently, it is important to test your own equipment to determine its actual performance.

When using strobe lights, be aware of the highest shutter speed at which a camera can be synchronized. When a flash photograph is taken with the camera's shutter speed set higher than the flash synchronization, some portion of the photograph will not expose. The flash synch speed can vary from a maximum of 1/30 of a second with some older 35mm camera systems to 1/250 of a second on some of today's more advanced systems.

Most professional medium-format camera systems utilize leaf-shutter lenses which contain the shutter in the lens and can achieve flash synchronization at any shutter speed to 1/500 of a second.

Studio Strobes

Studio strobe systems are usually designated as such by virtue of their size, weight, and power output. These units require AC power, or generators, for location use. The obvious drawbacks to using a generator are that they are large, heavy, noisy, and expensive.

Powerful studio strobes usually have power ratings of 1,000, 2,000, or 4,000 watt-seconds. Again, this can mean different things with different brands, but any of these will have sufficient power for almost any photographic application.

Usually, the more power a pack has, the more watts is has. For example, you can use four flash heads connected to a power pack which has 1000 watts, and use them at 250 watts each. With a power pack of 2000 watts, you could use the same four heads at outputs up to 500 watts each.

For people photography, it is not how much power you have but what you are able to do with it. If you want to light a large group and have to place

Photographic umbrellas can be many different sizes and materials.

This umbrella has a highly reflected silvered lining. This type of lining creates a light which is more specular than a white umbrella.

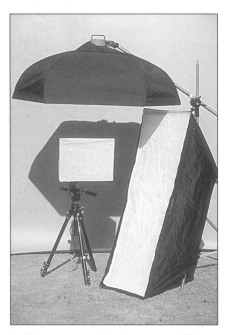

Soft boxes can also be many different sizes and shapes from round to rectangle.

your lights twenty feet from the group to achieve even illumination, you want all the power you can get.

If, however, you are lighting a single person with your lights four feet from the subject, you need more lighting knowledge and finesse than power.

Location Strobes

Battery portable strobes are powered by rechargeable batteries rated at 200 or 400 watt-seconds. Recycle times vary for these units, averaging around one second at full power.

Modifications to color temperature, intensity, quality, and direction will be the same as for the more powerful studio strobes.

Controlling Strobe Intensity

The easiest method for controlling the intensity of a flash unit is to adjust the power setting. The head may also be moved in relation to the subject. When moving the flash, keep the flash/subject axis the same.

With most studio strobe power packs, power can also be decreased by "bleeding-off" power to an additional strobe head. This is done by attaching an additional strobe head to the power pack. Power is diverted to this head, decreasing the power going to the other heads.

If you have an adjustment on your strobes which allows you to control how much power goes to this extra head, you can fine tune the power to exactly where you need it.

Once you have added another head to bleed off power, remove it from the room, or cover the flash tube so the light does not cast unwanted light onto the subject or set. **Note:** If the extra head has a modeling light, turn off the modeling light before you cover it; otherwise, you will damage the light or the cover.

Neutral density gel material allows a photographer to decrease the light intensity of a source without changing the color temperature. Neutral density filtration is placed on the strobe, comes in many densities, and is rated in stops. These gels can be used singly or in combination.

Finally, you can also use any combinations of light shield, reflector and/or translucent panel to alter the light source as needed.

Grid Spots

Grid spots are discs with honeycomb centers which are mounted to the front of strobe head reflectors. These devices are designed to direct the light from a strobe head into a column of light of a specified degree of spread (i.e.. 5 degrees, 10 degrees, and so on).

Grid spots are usually used for hair lights and kicker lights and may serve to highlight the shoulders, hips, and legs of a model. At other times, grid spots are used to create "hot spots" on the background. Light from a strobe head with a grid spot is hard and directional and is best used in

conjunction with a key or fill light. Grid spots also allow light to be directed to a specific area of a scene without having to worry about light spilling.

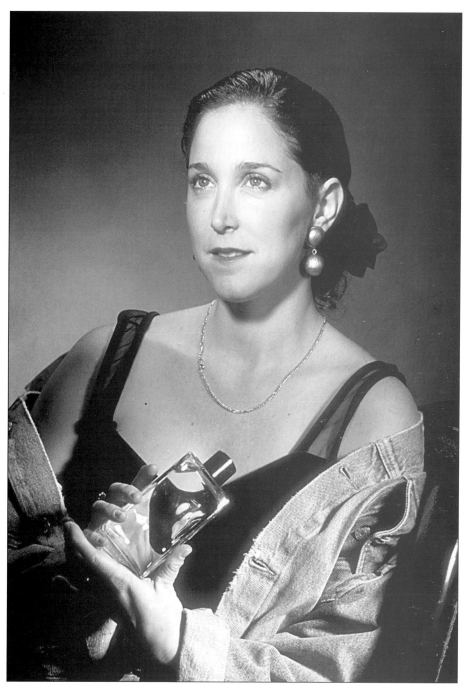

Here, one grid spot is used for a background light, a second light with grid spot is directed at the model's face, and a third light with grid spot is aimed at the model's hands.

Snoots

"THIS LIGHT CAN BE DIRECTED TO ANY POINT ON A BACK-GROUND..."

Snoots are cylindrical, tube-shaped light modifiers which funnel the light exiting the strobe tube into a controlled column of light. This light can be directed to any point on a background or within the photograph to create highlights similar to those created by grid spots.

Chapter Five Exercises

EXERCISE I: CONTROLLING INTENSITY OF STROBE LIGHTS

Objective: To evaluate techniques of controlling the intensity of electronic strobe lights with neutral density gels and strobe placement. (This exercise will take an hour or two if done at one sitting.)

Supplies needed: Camera and lens, tripod, model, one roll of slide film, strobe unit, light stand, flash meter, soft box or umbrella, neutral density gel material (one sheet each of 1/2 stop and full stop).

Instructions:

Part One

1. Start this exercise with an aperture of around f/11.0. This will allow you to open up enough to compensate for proper exposure.

2. Place the model on a stool or chair so he or she is comfortable. The model should be five feet in front of a white or gray wall or backdrop.

3. Set the camera on the tripod in front of the model, and frame the shot to include at least a foot of background on both sides of the model.

4. Set the strobe on a light stand just to one side of the camera at a height slightly higher than the model's face. If you are using an umbrella or soft box, place the strobe at a distance from the model equal to the size of the umbrella or box you are using. (Example: if you are using a 32 inch umbrella or soft box, place the strobe 32 inches from the model.) This will result in a soft, pleasing light. Adjust the light so the soft box or umbrella is aimed directly at the model.

5. Meter the intensity of the strobe's output at the subject's face, and adjust the camera aperture and shutter speed accordingly.

6. Make a series of exposures at these indicated settings.

7. Place a full-stop ND gel filter over the flash tube so that the output of the strobe is reduced one full stop. You may use a 1/2 stop ND filter doubled. If you have to cut the gel to fit completely over the flash tube, use gaffers or duct tape to keep it in place.

8. Adjust the camera settings to compensate, and make a series of exposures.

9. Add ND gels to decrease the light intensity an additional 1 1/2 stops. Adjust your camera, and make another series of exposures.

EXERCISE I — SUPPLIES

❏ Camera and lens
❏ Tripod
❏ Model
❏ One roll of slide film
❏ Strobe unit
❏ Flash meter
❏ Light stand
❏ Soft box or umbrella
❏ Neutral density gel material

10. Have your film processed, and evaluate the results. The subject in each of the exposures for this exercise should have the same density. Have the processing laboratory read the density of the highlight side of the model's face. If the density values vary more than a small amount, there is a problem with the readings; either the camera was not adjusted properly or the meter was not read properly. It is important to hold your light meter the same for each and every reading you take. The exercise should be repeated until the readings become consistent.

Part Two

1. Place the strobe ten feet away from the model, and position it for a Rembrandt lighting pattern.

2. Adjust the power output of the strobe so that the intensity of the light is f/8.0 at the subject's position.

3. Make a series of exposures at this setting.

4. For the next series of exposures, move the strobe unit two feet closer to the model along the flash-to-subject axis.

5. Using power control settings on the flash, adjust the power output so that the exposure indicated by the flash meter remains at f/8.0. If the intensity of the strobe cannot be decreased enough to accomplish the f/8.0 exposure, use ND gels.

6. Make another series of exposures.

7. Move the strobe unit to three feet from the model, and adjust the exposure to f/8.0 using the output adjustment of the strobe, if possible. If your strobe cannot be adjusted, use a combination of output settings and ND filters to achieve an output of f/8.0. Make a series of exposures.

8. Have the film processed and evaluate the results. All of the exposures for this part of the exercise should have exactly the same exposure and density on the film. If the results differ visibly, repeat the assignment until the results are identical.

9. Evaluate the difference between the highlight and shadow areas on the subject's face. Pay close attention to the changes that occur as the flash-to-distances change. Note how the depth of light decreases as the flash-to-subject distance decreases. This illustrates how you can keep the subject exposures constant but vary the background exposures without moving your subject or background.

EXERCISE II — SUPPLIES

- ❒ Camera and lens
- ❒ Tripod
- ❒ Model
- ❒ One roll of slide film
- ❒ Strobe unit
- ❒ Flash meter
- ❒ Light stand
- ❒ One umbrella & one soft box of similar size
- ❒ Diffusion panel

EXERCISE II: LIGHT QUALITIES OF STROBE UNITS

Objective: To evaluate the different qualities of light available from one strobe unit.

Supplies Needed: Camera and lens, tripod, model, one roll of slide film, strobe unit, light stand, flash meter, one photographic umbrella & one soft box of similar size, one diffusion panel.

Instructions:

1. Place the model in a comfortable position and set up the strobe eight feet away on a light stand. Use a butterfly lighting pattern for the entire exercise. (See page 45.)

2. Take a series of exposures using no light modification.

3. For the second series of exposures, place the umbrella on the strobe, and meter the strobe from the subject's position. Adjust your camera. Make your exposures.

4. For the third series of exposures, remove the umbrella and replace it with the soft box. Again, meter your subject, and make a series of exposures.

5. Move the strobe unit to a position four feet from the model, and repeat the three series of exposures [steps 2-4 above].

6. Place a diffusion panel in front of the strobe head. Place the panel about one foot in front of the strobe. Make sure the strobe illuminates the center of the panel. The strobe should be directed to shoot through the panel, directly toward the model.

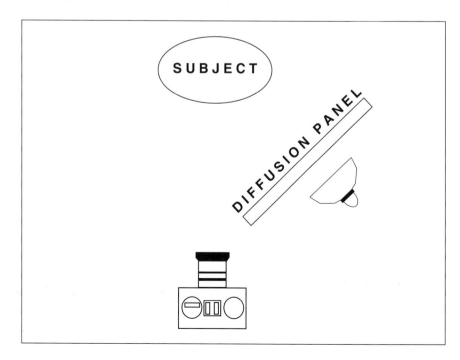

Above: *This shot was taken with a Canon EOS 1 and 300mm f/2.8L lens. Direct daylight was used to emphasize color and texture with a gold reflector behind the model to rim light her leg and arm. I used the lens wide open to blur the background and separate the model from the distracting environment.*

Above: *Using setting sunlight, I placed the model and her dog on the beach and photographed her as the light fell behind the evening horizon and began to warm. It was made with a Hassleblad 500c/m and 150mm lens set to 1/250 sec and f/4.0.*

Right: This lifestyle shot was taken with natural sunlight just before sunset. The directional light provides modeling which brings out shape and form. Taken with a Canon camera and 300mm f/2.8L lens wide open.

Right: I found a courtyard with great atmosphere for this fashion shot. The light was broken up by tree branches to create tension in the photograph. The site was chosen to compliment the garment's combination of colors. No supplemental lighting was needed.

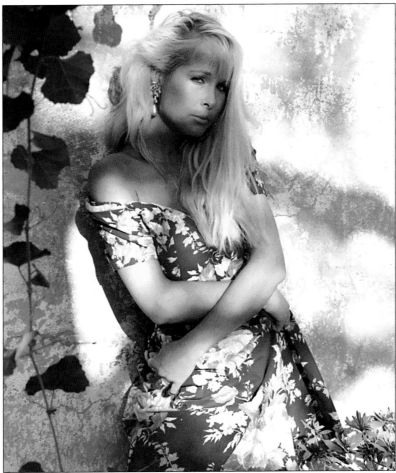

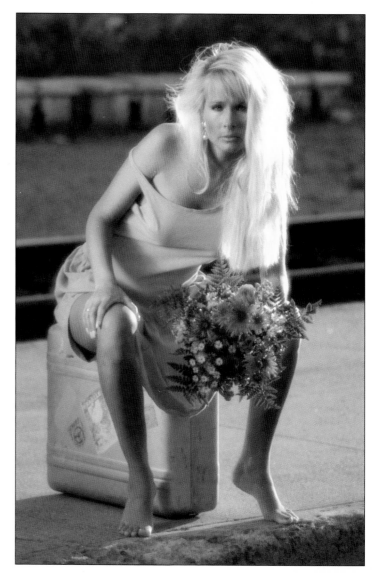

Above: *This photo was taken on the roof of my downtown Denver studio. Direct daylight was used to light the model and I used fill flash to soften shadows. I used a Canon EOS 1 and 80-200mm lens at f/2.8.*

Right*: Direct sunlight was used from behind the model to light her hair and provide edge lighting. A gold reflector was used to bounce light onto the model's face. A Canon EOS 1 camera and 300mm f/2.8L lens was used to take this photo.*

7. Make a series of exposures.

8. Move the strobe head away so that it fills the entire diffusion panel without spilling.

9. Make a series of exposures.

10. Have the film processed and carefully evaluate the results for changes in hardness and specularity. Compare the two umbrella series, the two soft box series, and the two unmodified series. Specularity is evaluated by the highlights seen on the model's skin and hair. As the light gets closer to the model, the light should become noticeably softer.

EXERCISE III: CONSTRUCTING A LIGHTING SET UP

Objective: Construct a lighting set up using multiple strobe units to control the color temperature, quality, and intensity of strobe light.

Supplies Needed: Camera and lens, tripod, model, strobe pack with three heads or three mono lights (self-contained individual strobes), one roll of slide film, flash meter, one sheet each of Roscoe (or similar): 1/2 CTO gel, 1/2 CTB gel, primary colored gel (red, blue, green), three light stands for the strobes, two soft boxes or umbrellas (or one of each). This exercise is to be performed indoors. Additional supplies that can be used if available: two black flags, seamless background, grid spot.

Instructions:

1. Place the model about six feet from the background

2. Set up your camera on the tripod and compose your photograph for a 1/2 length portrait (waist up).

3. Place the key light about six feet, to either side of the model, and about 45 degrees from the camera.

4. Place the fill light next to the camera, on the opposite side of the key light.

5. Adjust the key light for f/8.0, and set the fill light for f/5.6. When metering for the key light, remember to block all fill light from striking your meter's dome. Do the same when metering for the fill.

6. Place the third strobe behind the model to serve as a back light.

7. Place the back light above and behind the subject so that it illuminates the entire model but does not shine into the camera lens. Set the exposure for the back light equal to that of the key light.

8. With your lights metered and adjusted, make a series of exposures.

EXERCISE III — SUPPLIES

☐ Camera and lens

☐ Tripod

☐ Model

☐ Strobe pack with three heads or three mono lights

☐ One roll of slide film

☐ Flash meter

☐ One sheet of each of Roscoe: 1/2 CTO gel, 1/2 CTB gel, primary colored gel

☐ Three light stands for strobes

☐ Two soft boxes or umbrellas

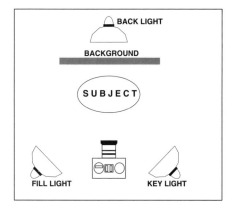

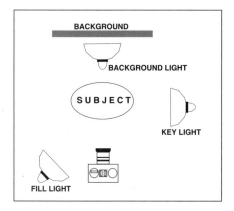

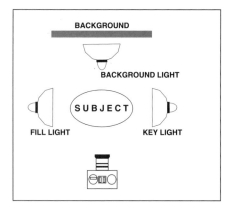

9. For the next series of exposures, place a soft box or umbrella over your key and fill lights.

10. Adjust the exposure for the modified key and fill lights to match the last series. Make a series of exposures.

11. For the next set of exposures, use a color temperature meter if one is available. Adjust the key, and fill light to a color balance of 4,500 degrees Kelvin. Adjust your back light to a temperature of 6,500. If no color meter is available, cover the flash tubes of the key and fill light with two layers of 1/2 CTO, and cover the back light with two layers of CTB.

12. Turn your back light around 180 degrees so that it is a background light. Cover this light with your red, green, or blue gel. Adjust this light to two stops less than the key light by metering the light at the background.

13. Make a series of exposures with the background light set at two stops less than the key light. Make another series of exposures with the background light adjusted for one stop less than the key light, equal to the key light, one stop greater than the key light, and two stops greater than the key light.

14. For the next series, move the key light to the side of the model (90 degrees off the camera-subject axis). Place three layers of CTO over the key strobe tube. Adjust this light to an intensity of f/8.0.

15. Now move the fill light opposite key light. Adjust this light to an intensity of f/5.6. Make a series of exposures with this set-up.

16. Have the film processed and evaluate the results. You will see the effect of over and under exposure on the colored background gels in relation to the subject's exposure. Analyze the various lighting set-ups and their effect on the subject. Also, observe the difference between unmodified light and modified light with warming gels. It is important to know how filters will affect the feeling of a photograph and how much warming or cooling is appropriate for the overall scene.

Chapter Six

Controlling Natural Light

Think of natural light as sunlight. Starlight and moonlight are far too weak for people photography. From the earliest break of dawn to the final light of day's end, the appearance of natural light will be affected by cloud cover, time of day, season, and altitude.

• **The appearance of natural light changes due to cloud cover, time of day, season, and altitude.**

One of the most difficult aspects of working with natural light is the inability to control the light source. Another dilemma that occurs is the continuous movement and changing quality of the source. Because of this, careful preplanning must be done for set-ups. If the set up takes too long, the entire scene may have to be shifted to compensate for the sun's movement.

This is especially true when working early mornings and late evenings. To avoid a problem, plan set-ups in a position in front of the sun's arrival — let the sun come to you. By watching the sunrise or sunset on a day prior to the planned shoot, the time and location of the sunset can be determined in advance. Check the position of the rising or setting sun as close as possible to planned shoot dates.

Controlling Color Temperature

The color temperature of daylight can be modified by on-camera filtration. (See page 11.) A color temperature meter will provide accurate means of adjusting filtration appropriately. Remember, the color temperature of natural light is changing from daybreak to sunset.

• **You can control the color temperature of daylight by using on-camera filtration.**

When individual photographs are taken, tight control of changing color temperatures may not be a serious consideration. However, when photographing any continuing project (such as a catalogue), keeping the color temperature of the entire project consistent can be essential to producing professional results.

When you need to modify the color temperature of a specific portion of a scene, it can be done by using reflectors to light only that portion. Required filtration may be applied to the reflector to achieve a specific color temperature leaving the rest of the scene unaffected. Remember that any gel placed on a reflector is doubled in intensity. This is because the light is

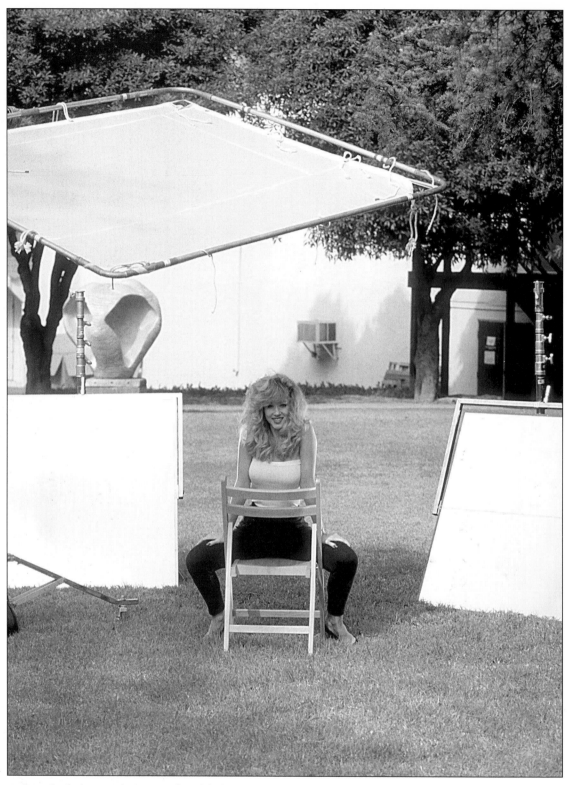

Direct daylight can be a very hard light, casting deep shadows. The controlling natural light set-up includes an overhead diffusion with reflectors for separation.

Because the model is looking directly into the sun, she is squinting to keep from hurting her eyes. This creates and unpleasant look on the model's face and will usually result in an unflattering photograph.

The model now has her back to the light. This reduces stress and softens the light in the model's face. It also creates a nice backlight on the model's hair.

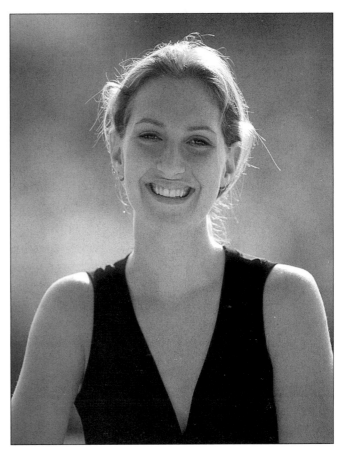

modified when it passes through the gel en route to the reflector, and once again when it passes through the gel from the reflector to the model. Due to this, use half of the color compensation suggested by the color meter.

Controlling Intensity of Natural Light

Intensity may be one of the easiest properties of natural light to determine; however, modifying the intensity of natural light can be tricky. The easiest way to control the intensity of natural light is to adjust the aperture or shutter speed of the camera. This is adequate for some tourist photography, but a specific aperture may be desired for a specific depth of field.

The easiest ways to reduce the intensity of light striking a model are to move the subject into a different light, or turn the model so that the sun strikes him or her from a different direction. In many cases, fill light can be added to the model's face with reflectors. This is impractical for preselected backgrounds. In this instance, control the intensity of natural light using neutral density filtration.

Selecting the appropriate film for the job will lessen your need for neutral density material. For example, with an early afternoon shoot set in the shade of a grove of trees, you might use ISO 100 film at 1/250 second at f/4.0. With ISO 400 film you would need to set your camera at 1/1,000 to maintain f/4.0. This, however, is not possible for a medium format professional camera with a maximum shutter speed of 1/500 second.

Direct Daylight

Direct sunlight is generally the hardest natural light to work with successfully, but it can be used to examine texture and define shape better than almost any other lighting. When controlled properly, direct sunlight can provide unsurpassed photographic results.

Although the sun is a very large source of light, it works as a small point light source because of its great distance from earth. The result of this small light source is deep shadows and high contrast ratios (six to seven stop range) with sharply defined highlight-to-shadow transfers. This contrasty light can cause trouble because photographic papers lack the ability to reproduce the contrast range. To minimize the high contrast, the subject can be repositioned (or turned), moved, or the light can be modified.

Direct Daylight from Behind

Back lighting, with the key light, can be attractive for people photography and is utilized often by a great number of professional photographers. Back lighting separates the subject from the background and results in almost shadowless lighting on the subject's face. One potential problem with back lighting is that the subject's face may be underexposed up to four stops, or the back light might be overexposed. This ratio can be narrowed by filling the subject's face (front) with reflector fill lighting. By using a reflector for frontal fill, the color of the fill light can be modified warmer or cooler without effecting the color temperature of the back light. This can be used for a stunning effect when you want to warm the subject's face without changing the background or other parts of the scene.

"...MODIFYING THE INTENSITY OF NATURAL LIGHT CAN BE TRICKY."

• **The hardest natural light to work with is generally direct sunlight.**

Because the key light originates from behind, the front of the model is underexposed.

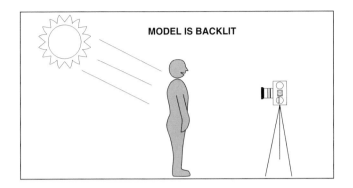

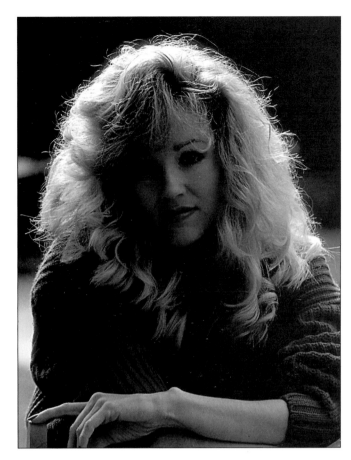

Backlit model with a reflector fill. In this photo, a reflector was brought in to fill the model's face.

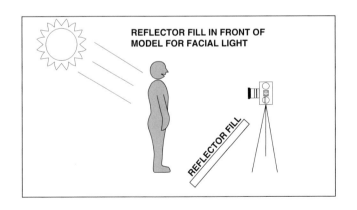

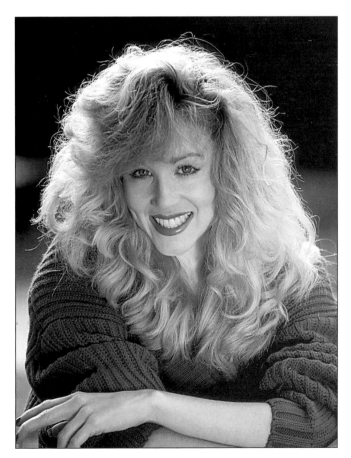

Light like that found beneath building overhangs, under trees, and on heavily overcast days is soft and shadowless. This photograph was taken beneath very dense trees with a Canon 300mm f/2.8L wide open.

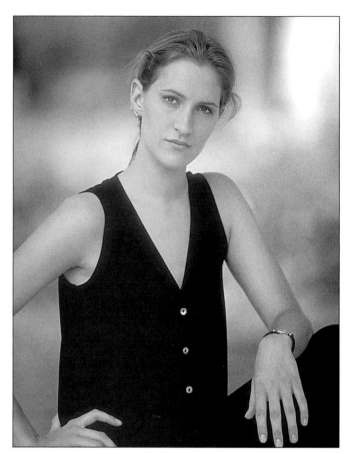

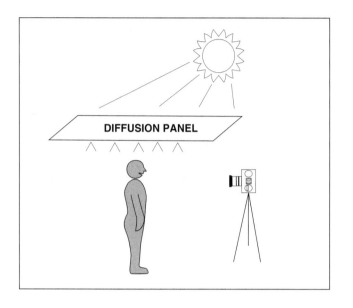

This example of diffused daylight was made with a large diffusion silk over the model to soften midday sun. A reflector was used behind the model for separation and edge definition.

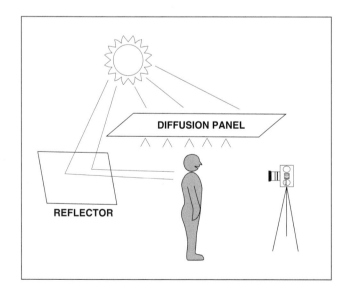

"Side lighting can be used creatively to examine textures."

Direct Daylight from the Side

Side lighting can be used creatively to examine textures, or to show depth and form. If the sun is low enough in the sky that it results in true side lighting, part of the model will be revealed and the other part will remain in shadow. A fill light or reflector can provide enough light for the exposure of shadow areas. With portable strobes, this fill can be easily controlled to provide just the right amount of light.

Diffused Daylight

Diffused natural lighting can be very pleasing light for people photography. It opens up shadows, lowers contrast and can result in attractive, subtle colors. Diffused natural light can occur early and late in the day, or on overcast days when the sky acts like a giant soft box. Use an 81B filter when photographing in open shade or on overcast days for good results. Also, photographing beneath natural or man-made obstructions such as buildings, trees, hills, and mountains, can result in very appealing, low contrast light.

Light in shade can very often have a slight color shift and should be corrected. For example, light beneath tree branches will not only be slightly bluer than the light in open sunlight, but it will often pick up a green color shift from the light reflecting off the tree's leaves. Correct for this by metering the color temperature of the ambient light and applying the proper filtration to the camera lens. Generally, only a small amount of magenta filtration (the opposite of green) will need to be added to the camera lens to compensate for the green shift. The color temperature meter will indicate the exact amount.

When working under trees or foliage, be aware of potential problems such as light coming through tree branches and creating patches of light on the model. Generally a minor pose change will correct for this; however, it may be necessary to find an area with thicker foliage to block the sun.

Chapter Six Exercises

EXERCISE I: CONTROLLING COLOR TEMPERATURE OF DAYLIGHT

Objective: To practice controlling the color temperature of daylight.

Supplies Needed: Camera and lens, tripod, model, one roll of slide film, exposure meter, color temperature meter, gel filters one each; 81, 81A, 81B, 81C, 81D, 81EF, 85C, 85, 82, 82A, 82B, 82C, 80D, 80C, 80B.

Instructions: Plan to do this exercise over several days.

1. Place the model in direct natural lighting. Keep the direction of the light consistent on the subject in each of the following series of exposures. Adjust the color temperature meter to give filtration readings for 4500 degrees Kelvin if possible.

2. Make a series of exposures at each of the following times in direct sunlight: within one hour after sunrise, at midday, around three p.m., and at sunset.

3. Make a series of exposures at the same times in diffused daylight.

4. Make sure to take meter readings and make modifications carefully, recording each step so you can refer back to them when analyzing the results. Have the film processed at a color laboratory. Each frame exposed should appear to have the same color temperature. If there are any obvious differences between the different series, meter readings aren't taken properly or gels are not being applied correctly. Re-shoot the assignment until consistent results are achieved.

EXERCISE I — SUPPLIES

❏ Camera and lens
❏ Tripod
❏ Model
❏ One roll of slide film
❏ Exposure meter
❏ Color temperature meter
❏ Gel filters

• **If a color temperature meter is not available, use the color temperature averages provided in Chapter One to anticipate the color temperature of the daylight at the times chosen to do the exercise.**

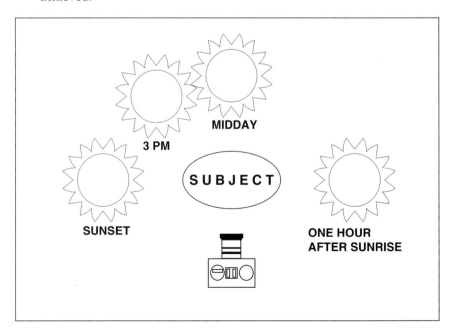

EXERCISE II — SUPPLIES

- ❑ Camera and lens
- ❑ Tripod
- ❑ Model
- ❑ One roll of slide film
- ❑ Color temperature meter
- ❑ Exposure meter
- ❑ Diffusion panel
- ❑ Stands or assistant
- ❑ Gel filters
- ❑ Reflector/fill card

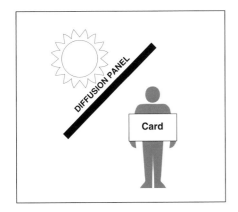

EXERCISE II: MODIFYING DIRECT AND DIFFUSED DAYLIGHT

Objective: To modify direct and diffused daylight to appear similar in color temperature.

Supplies Needed: Camera and lens, tripod, model, one roll of slide film, color temperature meter, exposure meter, diffusion panel, stands or assistant to support diffusion panel, gel filters (from exercise I), reflector/fill card.

Instructions:

1. Place the model in direct sunlight, and diffuse the light with a diffusion panel.

2. Using a fill card in front of and below the model's chin, fill the shadows beneath the face.

3. Take a color temperature and exposure reading at the model's face, and adjust the exposure and color balance.

4. Make a series of exposures.

5. Move the model into diffused daylight.

6. Take a color temperature reading and an exposure reading, then filter to bring the light equal to the first series of this exercise. (If you do not have a color temperature meter, make a series of shade exposures with an 81A, an 81B, an 81C, and an 81EF filter on your camera lens.)

7. Have the film processed and examine the results. Just as with the first exercise, the two series should appear almost identical. If there is a difference between the two, evaluate the difference and re-shoot. If you did this without the aid of a color meter, compare the sunlight photograph with the four different filtered shots, and determine which one is most similar to the unmodified photograph.

CHAPTER SEVEN

Controlling Synchro-Sun Lighting

One ability that can separate a great photographer from an average photographer is competence in controlling mixed light (SYNCHRO-SUN LIGHTING ■). This chapter will show you how to work with strobe and natural light at the same time.

In the past, medium format equipment was a must when performing synchro-sun photography. This was due to the high flash synch capability of leaf-shutter lenses found in most professional medium format equipment. Until recently, 35mm camera equipment only had a flash synch capability of 1/60 second, which did not allow for easy mixed lighting photography.

Today, much professional 35mm camera equipment has a flash synch capability of 1/250 second rivaling medium format speeds. This allows a photographer to photograph outdoors with an ISO 64 professional film at a shutter speed of 1/250 second at an aperture of f/8, and still use a strobe unit for fill light.

When using available light for people photography, the photographer has four options:

- he can use the light as he finds it;

- he can turn the model so the light illuminates the model from a more acceptable direction;

- the model can be moved into different light;

- or the existing light can be modified to meet the photographer's needs.

Because the majority of synchro-sun photography is performed on location, the easiest strobe equipment to use is battery portable flash equipment. This equipment is usually smaller, lighter, cheaper, and requires no electrical cords or generators. When more power is required, studio strobes, and generators or AC power cords, will have to be used.

■ SYNCHRO-SUN LIGHTING

The use of natural and strobe lighting together.

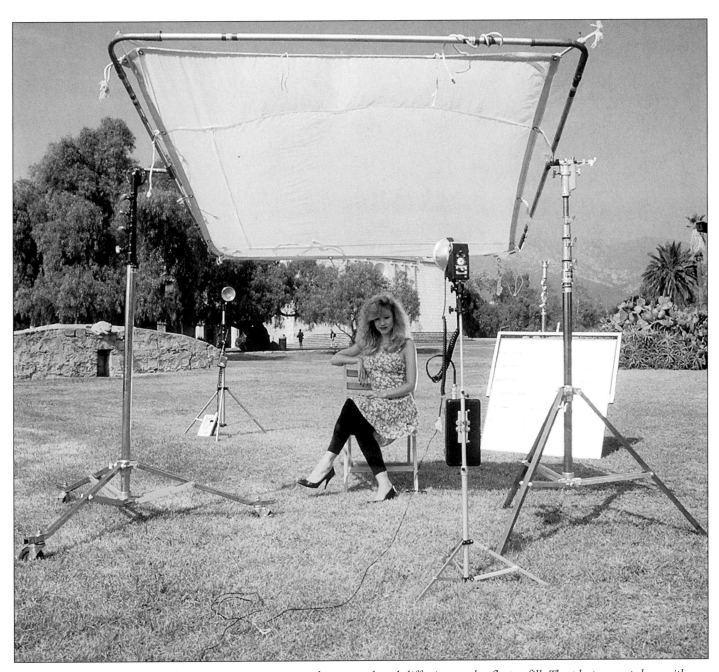

This setup shot was taken to demonstrate one way to achieve overhead diffusion and reflector fill. The photo was taken with a Canon A2 camera and a Canon 28-80mm lens. Camera settings were 1/250 sec at f/4.0.

The ambient light was metered to determine the exposure value for the background. Then the output from a battery portable strobe was set to provide an exposure value 1 stop less than that of the ambient light. This results in an acceptable exposure range for transparency film.

If your goal is to emphasize the subject more than the background, you can increase exposure by using a strobe to increase exposure value for the main subject. Once exposure values are adjusted, set the camera for the exposure value for the main subject.

The equipment for modifying strobe light on location is the same as in the studio: soft boxes, umbrellas, diffusion panels, reflectors, and filtration. Use twice the ballast (sand bags) than would be used in the studio since there is an increased possibility of persons tripping over equipment and because of unpredictable weather conditions.

One of the really exciting aspects of shooting outdoors with mixed lighting is that the photographer has the choice of what to use for key and fill light sources. Each can be used from any direction: from the front, side, back, or overhead. The photographer must understand both how light behaves and how to manipulate it. You have the choice of using strobes or reflectors to hide or illuminate any feature of the scene. You can increase contrast in an inherently flat scene by using strobes, or you can flatten an existing scene by using fill light. It comes down to controlling light rather than light controlling the scene.

Sun From Behind with Strobe Fill

When the sun is used as a key light from behind the subject, strobes can fill from the front to reduce total contrast. Strobe fill for back-lit situations can also fill shadows in clothing and bring the scene's contrast into range for the film. Generally, you don't want to create new shadows on the face with fill lights so an umbrella or other soft light source is suggested.

When the sun is low behind the subject, there will not be distinct shadows on the face. Ambient daylight coming from behind will provide adequate separation of model and background, so you don't have to worry about flattening out the photograph. Remember, there are no strict rules about fill-light brightness, but you should try to avoid creating an unnatural appearance.

The photographer must be aware of how the subject will appear in the final photograph. If you have a back-lit scene and you want to fill the subject to blend with the environment, you would use the 1/2 stop under exposure for the face. However, if your desire was to eliminate the background because of some unwanted details behind the subject, you could fill the subject to 2 stops over the back light and render the background darker and less important.

Midday Overhead Sun

When photographing at noon on a clear day, shadows cast by the sun will be very harsh. This very hard lighting, left unmodified, can result in deep shadows (raccoon eyes) and high local contrast. Shadows this deep can be filled by decreasing the overall contrast with a diffusion panel overhead, and/or by using fill strobes. It is advised that you diffuse the overhead light then fill.

One problem that arises is that even though the local contrast decreases with the placement of a diffuser, the total contrast increases because the background remains the same as before. If this contrast range is inappropriate, additional light can be added to the model with reflectors and strobe units.

- **When shooting outdoors, you can choose what to use for key and fill light sources**

"...MUST BE AWARE OF HOW THE SUBJECT WILL APPEAR IN THE FINAL PHOTOGRAPH."

- **Midday overhead sun, on a clear day, creates very hard lighting and high local contrast.**

This photograph was taken with a Canon A2 and a 300mm f/2.8L lens set at f/5.6. The subject is under a diffusion flat to soften the ambient light and then lit with a strobe to balance exposure with the background.

Above: *Sometimes a model and light is all you need. In one of my favorite spots, I placed the model in the late afternoon light and shot using no artificial lighting. I used a 300mm f/2.8L lens wide open and an 81D filter for additional warmth.*

Left: *Two lights were used to make this shot work. One was used in a large umbrella in front of the model and the second was used to light the background and the model's hair. This shot was taken with a Bronica ETRS and a 150mm lens.*

Right: *While scouting locations for a product shot, I drove around a corner and found the sun dropping behind some clouds. We stopped and I placed the model on a bus stop bench. This shot was done in about two minutes with existing soft diffused skylight. Camera settings were 1/250 sec at f/2.8.*

Right: *Glamour is what it's all about. Three lights make this shot easy. A large soft box was used above the camera. A second soft box was placed on the ground below the model's face. The third light was a bare bulb used to light the model's hair.*

Lighting Effects

Key Light
Key or main light is that which creates the dominant visible shadows on the subject. The key light will generally be from one source. It can be from any source or any type of light.

Hair Light
This back light highlights the subject's hair. It emphasizes hair texture and provides separation between the subject and the background. Do not over light the hair as this will result in loss of detail.

Fill Light
A fill light is any light which is used to bring out the detail in shadow areas. It reduces the contrast ratio of the scene by illuminating areas that would otherwise be underexposed. It is never more intense than the key light.

Background Light
This light is placed behind the subject and directed at the background. It can add to the ambiance and depth of a photograph. A grid spot or snoot will allow you to place strobes farther away.

Front Light
This light comes primarily from directly in front of the subject. Direct frontal lighting flattens the appearance of the subject because it does not cast shadows that are visible to the camera.

Rembrandt Lighting
This pattern lights the subject's face from about 45 degrees to one side and creates strong shadows. Using this lighting pattern divides the face into two sides and gives shape and depth to the model's features.

Side Light
Light striking the subject from 45 to 90 degrees off-axis is considered side lighting. This type of lighting creates strong shadows. It can be very flattering and is a great tool for creating a mood.

Butterfly Lighting
This lighting pattern uses key light which originates from the camera position and casts a shadow directly below the nose. The brightest area will be between the eyes, and the face will be evenly lit.

Rim Light
Light that comes from behind helps separate the subject from the background. It is usually adjusted to provide separation without dominating the image.

Split Lighting
In split lighting, the key light comes at the subject from the side. The subject is "split" by the key and fill light, dividing the subject's face into two equal parts.

Back lit subject without flash fill. A subject can be turned away from the sun to avoid harsh shadows on the face, but fill light may be required to avoid underexposure of the model's face.

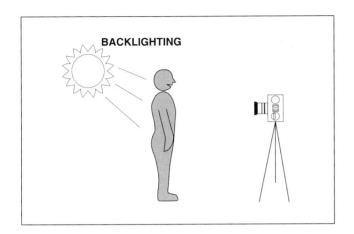

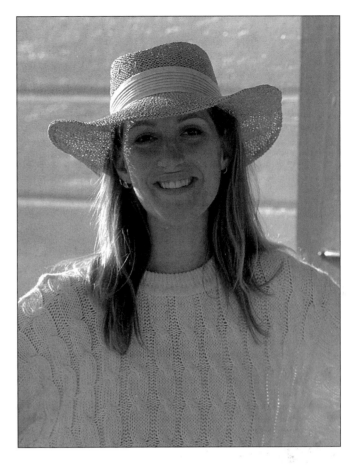

Back lit subject with strobe fill. Compare this result with that of the above photograph. You can see how the fill strobe was used to balance this exposure. Exposure was 1/200 sec at f/4.0.

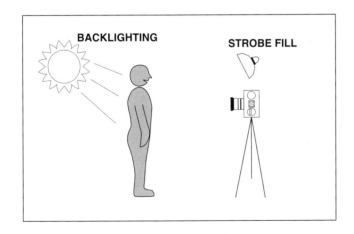

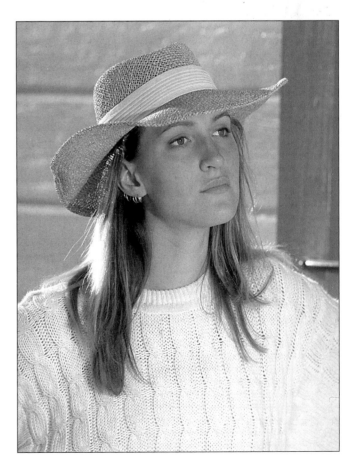

• **You can quickly evaluate your lighting set up and exposures with the help of a polaroid test photograph.**

• **Polaroid film backs are available for all professional 35mm cameras and all medium format professional cameras.**

"IN TIMES LIKE THIS, USE STROBE LIGHTING TO AUGMENT THE AMBIENT LIGHT."

Sun From the Front with Strobe Fill

When daylight used for key lighting originates from the front of the model, the strobe fill can be placed near the camera position (to provide fill light), behind the model (for separation light), or both.

Increasing separation of a subject from the background can be handled in several ways:

• place a scrim between the model and the sunlight

• reposition the model

• use kicker lights

The intensity of the back lighting will be affected by the mood desired by the photographer. If the intensity of the separation or edge light becomes too intense in relation to the set exposure, the light will record as a white halo, revealing no detail. The halo may be distracting if it appears in the final photograph. It can also cause flare rendering the entire photo washed out or lacking in contrast. It is a good idea to limit a back light's intensity to one stop more than the frontal fill. You can practice this control in this chapter's first exercise.

Using Flash to Augment Ambient Daylight

At times, the ambient light is strong enough to illuminate a background, but not bright enough for the key exposure. The softest or most desired existing light temperature (just before sunset or sunrise) may not be strong enough for proper exposure. In times such as this, use strobe lighting to augment the ambient light.

It is also possible to use the strobe for the key light and a reflector for fill. A variation of this would be to use one strobe for the key light from behind, another for the fill light, and natural lighting for the background.

This photo is an example of unmodified daylight. You can see deep shadows in the model's eyes. This photo is contrasty and harsh.

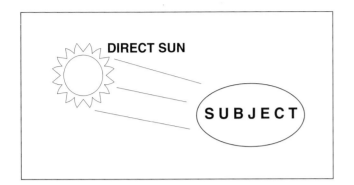

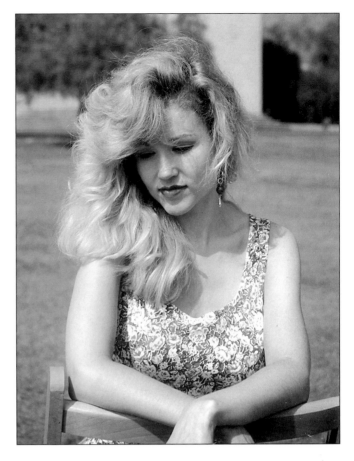

In this photo (compare to above), a diffusion panel was used to soften the hard natural light. A portable strobe was used to soften shadows on the model's face. Also, a reflector was used from behind to highlight the model's hair.

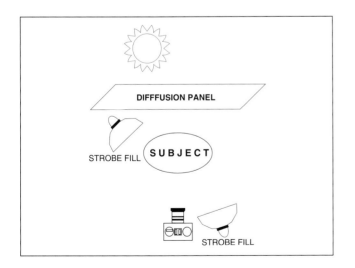

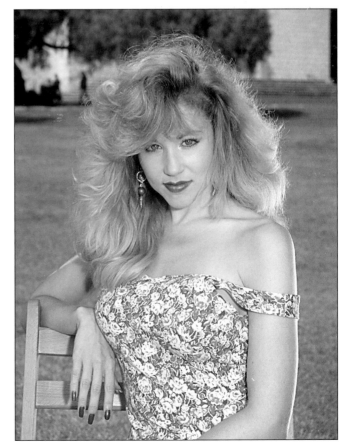

Chapter Seven Exercises

EXERCISE I: USING A STROBE FILL

Objective: To practice the use of strobe fill in a back-lit scene.

Supplies Needed: Camera and lens, tripod, model, one roll of slide film, strobe unit, incident light meter, flash meter, light stand.

Instructions:

1. In early morning or twilight, place the model outdoors where ambient light will illuminate him or her from behind.

2. Place your fill strobe in front of the model at the camera position.

3. Use the largest aperture your lens has to isolate the model (i.e. f/2,8).

4. Take a light meter reading and set your strobe's intensity to provide fill two stops less than the back light. Adjust your exposure for the fill light, thus rendering your back light overexposed.

5. Make a series of exposures.

6. Make a series of exposures with the fill light at one stop, 1/2 stop less than the back light.

7. Now make a series of exposures with the fill light providing one stop more intensity than the back light. This will render your back light one stop underexposed.

8. Have the film processed and examine the results. You should be able to see how the main subject and your background work together to create an overall feel for your photography. Notice the difference in the effect when the background is one stop brighter than your subject versus one stop dimmer.

EXERCISE II: SYNCHRO-SUN PHOTOGRAPHY

Objective: To control synchro-sun photography at midday.

Supplies Needed: Camera and lens, tripod, model, one roll of slide film, diffusion panel, stands or assistants to support the diffusion panel, flash meter, light meter, strobe unit, reflector panel, stand for reflector panel.

Instructions:

1. Place the model in direct daylight around midday.

2. Place your camera in front of the model, compose a 3/4 shot or greater (at least head to knees), and take a

EXERCISE I — SUPPLIES

❏ Camera and lens
❏ Tripod
❏ Model
❏ One roll of slide film
❏ Strobe unit
❏ Incident light meter
❏ Flash meter
❏ Light stand

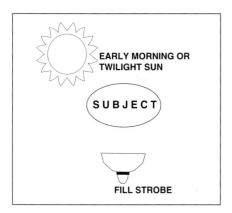

EXERCISE II — SUPPLIES

❏ Camera and lens
❏ Tripod
❏ Model
❏ Diffusion panel
❏ Stands or assistants
❏ Flash meter
❏ Light meter
❏ Strobe unit
❏ Reflector panel
❏ Stand

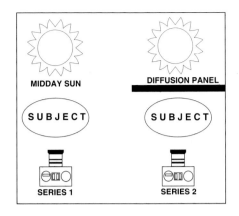

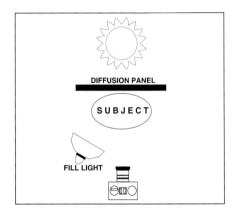

meter reading with your camera adjusted for the ambient light intensity.

3. Take a series of photos in direct, unmodified sunlight.

4. Now place your diffusion panel two feet above the model, between the model and the sun. The panel should diffuse all direct sunlight striking the model.

5. Take a meter reading of the intensity of light at the model's face beneath the diffusion panel. Adjust your camera, and make a series of exposures.

6. Set your fill light in front of the model to provide shadowless fill light on the model's face. Set the intensity of your strobe to provide a 2:1 ratio between the ambient light and the strobe (one stop less than daylight). Adjust you camera for the strobe fill and make a series of exposures.

7. Adjust your strobe light to provide a 1:1 ratio with the ambient light. Adjust your camera for this new exposure, and make a series of exposures.

8. For the next series of exposures, adjust the diffusion panel, or have an assistant hold the panel so that the ambient light strikes the model from behind only. All light from above should remain diffused. This can be done by moving the panel forward or tilting it to allow the sun to create edge lighting. This will allow you to achieve greater separation between the model and the background.

9. With the panel adjusted for edge lighting, make a series of exposures with a 2:1, 1:1, and 1:2 ratio between the background and the model. Make a series of exposures for each ratio, adjusting your camera to maintain proper exposure for the model's face.

10. Have the film processed and examine the differences between the various combinations. Examine the difference between direct overhead sun, diffused overhead sun, and diffused overhead sunlight with synchro-fill. Also, you will evaluate these with and without edge lighting. This will give you several situations to look at and decide which you like better. It will also give you an idea of how each changes the overall feel of the photograph.

Conclusion

Light is one of the most important aspects of photography. A photographer who is able to anticipate the way light will respond in varying conditions, and who can modify this light, will have a more complete understanding of photography. The intent of this book was to introduce you to lighting for people photography techniques. These techniques can be mastered through practice and experimentation. No suggestions given here are sole solutions to complex lighting situations. Rules lock a person into a right or wrong mentality which can be stifling. Use these guidelines to experiment with and test ideas. Among the most important things to keep in mind are knowing how to modify light and how to get predictable photographic results. This can only improve most aspects of your photography.

Glossary

ambient — Naturally existing available light used for photography.

aperture — The opening in a photographic lens through which light passes en route to the film plane. In most cameras, the aperture is variable and allows the photographer to control its diameter.

artificial light — Light from a lamp, photo strobe, incandescent bulb, florescent source or any other light not naturally occurring..

ASA — American Standards Association. The ASA designed a common system for rating the speed of a film emulsion.

back light — A light source which originates from behind the subject and is directed at the subject.

background light — A light directed at the background in a photographic scene. Used to provide separation of the subject from the background.

bounce light — Light which originates from one source which is redirected to a subject by bouncing it off another surface.

broad lighting — Lighting style used to broaden the appearance of a subject in photography. Produced by placing the key light on the side of a model's face which is closest to the camera.

butterfly lighting — Lighting style in which the key light creates a shadow which falls just beneath the subject's nose (also called Paramount lighting).

catch light — A specular highlight seen in the eyes of a photographic subject. This highlight is usually a mirror image of a light source being used to front light the subject.

chiaroscuro — The relationship between the light and shadow in a scene.

color compensating filters — Photographic filters used to adjust the color of the light entering a photographic lens.

color temperature— The common expression of a light's color quality usually expressed in terms of degrees Kelvin. The cooler the light, the higher its temperature. Conversely, the warmer the light, the lower its color temperature will be.

color temperature meter — A meter used for measuring the color balance of a light source. Contemporary color temperature meters suggest filtration required to balance the light to neutral.

contrast — The measure of lighting extremes, highlight, and shadow, within a scene. Usually indicated in terms of a ratio. See also local contrast and total contrast.

daylight film — Photographic film balanced for average daylight at 5,500 degrees Kelvin.

depth of field — The distance along a plane in front of and behind the point of critical focus that is within acceptable focus.

depth of light — The distance behind a subject at which point the exposure value begins to fall off noticeably.

DIN — Deutsche Industrie Norm. The German standards association which created one of the two major film emulsion sensitivity ratings. The DIN is used primarily in Europe.

direction of light — The direction in which the light being used for photography is traveling.

exposure — A stable image produced on a light-sensitive medium. An exposure is made by allowing light in the proper amount to contact a photographic emulsion.

fill light — A light used to fill (soften) shadows and reduce contrast.

film emulsion — The light-sensitive, image-forming coating applied to the surface of film. Emulsion consists of silver halide crystals suspended in gelatin or synthetic materials.

film speed — A film's relative sensitivity to light. Film's sensitivity to light increases as its rating increases. Film speeds are indicated as ISO/ASA ratings in the United States and Britain, and DIN in other parts of Europe.

filter — A transparent material, usually glass, acetate, or gelatin used to modify light entering a camera lens. Filters can also be used to modify light leaving a source.

flash meter — A meter designed to measure the intensity of a flash or strobe.

front light — A light which originates from in front of a subject.

f-stop — The numerical indicator of the aperture opening of a lens. Each progressively larger f-stop allows twice as much light as the previous f-stop.

gobo — A light-blocking tool designed to block all the light falling on a subject or scene. Originally designed for the motion picture industry as a "go between."

gray card (18%) — A card which reflects a known 18% of the light falling on it. Representative of the average reflectance of an average scene. Used to provide a standard for metering a light source for photographic work.

grid spot — A round light modifying tool with a honeycomb middle placed in front of a strobe head to direct the output into a controlled column of light of a specific size.

guide number — The numerical rating of a portable strobe's power output. Determined by metering a flash unit's output at ten feet with a light meter set at ISO 100 and multiplying that reading by 10. The proper exposure for a portable strobe unit can be calculated by dividing the guide number by the flash-subject distance (i.e. GN 110 ÷ 10 feet = f/11.0).

hair light — A light used to create highlights on a subject's hair.

hard light — Light quality which has clearly defined shadows with a discernible highlight to shadow transfer.

highlight — Brightest area of a subject or scene.

incident light — Naturally occurring light falling upon a scene.

incident light meter — A light meter designed to measure the light falling on a subject or scene.

inverse square law — A physical law which states that the intensity of illumination is inversely proportional to the square of the distance between the subject and the light source.

ISO — International Standards Organization rating for measuring film's sensitivity. Usually used in association with ASA/ISO. (See ASA.)

Kelvin — Temperature scale used to measure and indicate the relative color temperature of light in the electromagnetic spectrum.

key light — The light in a scene which casts the dominant shadows.

law of reflection — The law of physics which states that when light strikes an object at an angle, it is reflected off that object at the same angle.

lens flare — Internal reflections within lenses which decrease contrast and degrade the image.

lens hood — A light-controlling accessory placed over the end of the lens to reduce internal lens flare.

light intensity — The measured strength of light indicated in terms of f-stop at a specific film speed and shutter speed

light quality — The texture or "feel of light." It can be hard, soft, specular, or diffuse.

local contrast — The exposure extremes of highlight and shadow of the main subject in a scene.

loop lighting — Lighting style in which the key light produces a shadow from the subject's nose which falls on the cheek just above the lip line.

Paramount lighting — Lighting style in which key light creates a shadow which falls just beneath the subject's nose (also called butterfly lighting).

reflected light meter — A light measuring device designed to meter the light reflecting off of a subject or scene. In-camera light meters are reflected light meters.

reflector — A reflective material used to redirect light into a scene or onto a subject. Reflectors can be rigid or flexible and come in many colors and textures.

Rembrandt lighting — Lighting style in which the key light creates a drop shadow from the nose which falls on the subject's cheek and merges with the shadows on the unlit side of the face. This lighting style used by the artist Rembrandt divides the subject's face in two giving it shape and depth.

rim light — A light originating from the side of a subject opposite the camera creating a "rim" of light around the subject.

scrim — A light blocking tool designed to block a portion of light falling on a scene. Scrims are usually designed to block 1/2, 1, or 2 stops of light.

short lighting — Lighting style used to narrow the appearance of a subject. Produced by placing the key light on the side of the subject's face which is farthest from the camera.

shutter — A mechanical curtain inside a camera or lens which opens and closes upon demand to allow light to reach the film.

snoot — A cylindrical light modifying tool placed over the front of a strobe head to reduce the light output onto a small spot.

soft box — A light modifying device made of black nylon with a white diffusion panel on the front designed to place over a strobe and used to soften and enlarge a light source.

soft light — Light quality which creates minimal shadows with a very broad highlight to shadow transfer line.

specular light — Light quality which creates visible highlights on the subject.

split lighting — Lighting style in which the key light originates from directly to the side of the subject, casting half of the face in shadow.

spot meter — A special reflected light meter designed to meter light reflecting from a very small angle of view.

synchro-sun lighting — The use of natural and strobe lighting together.

total contrast — The exposure extremes of highlight and shadow within an entire scene.

translucent diffusion — A diffusion panel which transmits and softens light.

tungsten light — Ordinary incandescent light bulbs.

umbrella — A light reflector that diffuses light. Used with direct strobe light to soften and direct light onto the subject. Can be white, silvered, or gold lined.

Index

Other Books from Amherst Media, Inc.

Basic 35mm Photo Guide
Craig Alesse

Great for beginning photographers! Designed to teach 35mm basics step-by-step — completely illustrated. Features the latest cameras. Includes: 35mm automatic and semi-automatic cameras, camera handling, f-stops, shutter speeds, and more! $12.95 list, 9 x 8, 112 p, 178 photos, order no. 1051.

Wide-Angle Lens Photography
Joseph Paduano

For everyone with a wide-angle lens or people who want one! Includes taking exciting travel photos, creating wild special effects, using distortion for powerful images, and much more! Part of the Amherst Media's Photo-Imaging Series. $15.95 list, 7 x 10, 112 p, glossary, index, appendices, b&w and color photos, order no. 1480.

Infrared Photography Handbook
Laurie White

Totally covers black and white infrared photography: focus, lenses, film loading, film speed rating, heat sensitivity, batch testing, paper stocks, and filters. Black & white photos illustrate how IR film reacts in portrait, landscape, and architectural photography. $24.95 list, 8 1/2 x 11, 104 p, 50 B&W photos, charts & diagrams, order no. 1383.

Big Bucks Selling Your Photography
Cliff Hollenbeck

A complete photo business package for all photographers. Includes secrets to making big bucks, starting up, getting paid the right price, and creating successful portfolios! Features setting financial, marketing and creative goals. This book will help to organize business planning, bookkeeping, and taxes. $15.95 list, 6x9, 336 p, Hollenbeck, order no. 1177.

Wedding Photographer's Handbook
Robert and Sheila Hurth

The complete step-by-step guide to photographing weddings – everything you need to start and succeed in the exciting and profitable world of wedding photography. Packed with shooting tips, equipment lists, must-get photo lists, business strategies, and much more! $24.95 list, 8 1/2 x 11, 176 p, index, b&w and color photos, diagrams, order no. 1485.

Camera Maintenance & Repair
Thomas Tomosy

A step-by-step, fully illustrated guide by a master camera repair technician. Sections include: testing camera functions, general maintenance, basic tools needed and where to get them, basic repairs for accessories, camera electronics, plus "quick tips" for maintenance and more! $24.95 list, 8 1/2 x 11, 176 p, order no. 1158.

Glamour Nude Photography
Robert and Sheila Hurth

Create stunning nude images! Robert and Sheila Hurth guide you through selecting a subject, choosing locations, lighting, and shooting techniques. Includes information on posing, equipment, makeup and hair styles, and much more! $24.95 list, 8 1/2 x 11, 144 p, over 100 b&w and color photos, index, order no. 1499.

McBroom's Camera Bluebook
Mike McBroom

Comprehensive, fully illustrated, with price information on: 35mm cameras, medium & large format cameras, exposure meters, strobes and accessories. Pricing info based on equipment condition. A must for any camera buyer, dealer, or collector! $24.95 list, 8x11, 224 p, 75+ photos, order no. 1263.

Lighting for People Photography
Stephen Crain

The complete guide to lighting and its different qualities. Includes: set-ups, equipment information, how to control strobe and natural lighting, and much more! Features diagrams, illustrations, and exercises for practicing the lighting techniques discussed in each chapter. $24.95 list, 8 1/2 x 11, 112 p, b&w and color photos, glossary, index, order no. 1296.

Zoom Lens Photography
Raymond Bial

Get to know the most versatile lens in the world! Includes how to take vacation, landscape, still life, sports and other photos. Features product information, accessories, shooting tips, and more! Part of the Amherst Media's Photo-Imaging Series. $15.95 list, 7 x 10, 112 p, b&w and color photos, index, glossary, appendices, order no. 1493.

Great Travel Photography

Cliff and Nancy Hollenbeck

Learn how to capture great travel photos from the Travel Photographer of the Year! Includes helpful travel and safety tips, packing and equipment checklists, and much more! Packed full of photo examples for all over the world! Part of the Amherst Media's Photo-Imaging Series. $15.95 list, 7 x 10, 112 p, b&w and color photos, index, glossary, appendices, order no. 1494.

Infrared Nude Photography

Joseph Paduano

A stunning collection of natural images with wonderful how-to text. Over 50 infrared photos. Shot on location in the natural settings of the Grand Canyon, Bryce Canyon and the New Jersey Shore. $19.95 list, 9 x 9, 80 p, over 50 photos, order no. 1080.

Make Fantastic Home Videos

John Fuller

Create videos that friends and relatives will actually want to watch! After reviewing basic equipment and parts of the camcorder, this book tells how to get a steady image, how to edit while shooting, and explains the basics of good lighting and sound. Sample story boards and storytelling tips help show how to shoot any event. $12.95 list, 7 x 10, 128 p, fully illustrated, order no. 1382.

Build Your Own Home Darkroom

Lista Duren & Will McDonald

This classic book shows how to build a high quality, inexpensive darkroom in your basement, spare room, or almost anywhere. Information on: darkroom design, woodworking, tools, and more! $17.95 list, 8 1/2 x 11, 160 p, order no. 1092.

Into Your Darkroom Step-by-Step

Dennis P. Curtin

The ideal beginning darkroom guide. Easy to follow and fully illustrated each step of the way. Information on: equipment you'll need, set-up, making proof sheets and much more! $17.95 list, 8 1/2 x 11, 90 p, hundreds of photos, order no. 1093.

The Freelance Photographer's Handbook

Fredrik D. Bodin

A complete handbook for the working freelancer. Full of how-to info & examples. Includes: marketing, customer relations, inventory systems, portfolios, and much more! $19.95 list, 8 x 11, 160 p, order no. 1075.

Lighting for Imaging

Norman Kerr

This book explains light: what it is, how to use it, and how to control it. It shows how to use any light source for any form of photographic imaging — including film, digital, or video. Learn to use light like an expert: from taking videos of your family trips to polishing your professional work. $26.95 list, 8 1/2 x 11, 144 p, color and b&w illustrations, order no. 1490.

The Wildlife Photographer's Field Manual

Joe McDonald

The complete reference for every wildlife photographer. A practical, comprehensive, easy-to-read guide with useful information, including: the right equipment and accessories, field shooting, lighting, focusing techniques, and more! Features special sections on insects, reptiles, birds, mammals and more! $14.95 list, 6 x 9, 200 p, order no. 1005.

Camcorder Business

Mick and George A. Gyure

Make money with your camcorder! This book covers everything you need to start a successful business using your camcorder. Includes: editing, mixing sound, dubbing, technical and business tips, and much more! Also features information on covering a wedding or other special event for a client, legal and industrial videos, and more. $17.95 list, 7 x 10, 256 p, order no. 1496.

More Photo Books Are Available!

Write or fax for a *FREE* catalog:
Amherst Media, Inc.
PO Box 586
Buffalo, NY 14226 USA

Fax: 716-874-4508

Ordering & Sales Information:

Individuals: If possible, purchase books from an Amherst Media retailer. Write to us for the dealer nearest you. To order direct, send a check or money order with a note listing the books you want and your shipping address. U.S. & overseas freight charges are $3.50 first book and $1.00 for each additional book. Visa and Master Card accepted. New York state residents add 8% sales tax.

Dealers, distributors & colleges: Write, call or fax to place orders. For price information, contact Amherst Media or an Amherst Media sales representative. Net 30 days.

All prices, publication dates, and specifications are subject to change without notice.
Prices are in U.S. dollars. Payment in U.S. funds only.

Amherst Media's Customer Registration Form

Please fill out this sheet and send or fax to receive free information about future publications from Amherst Media.

CUSTOMER INFORMATION

DATE

NAME

STREET OR BOX #

CITY **STATE**

ZIP CODE

PHONE ()

OPTIONAL INFORMATION

I BOUGHT *LIGHTING FOR PEOPLE PHOTOGRAPHY* **BECAUSE**

I FOUND THESE CHAPTERS TO BE MOST USEFUL

I PURCHASED THE BOOK FROM

CITY **STATE**

I WOULD LIKE TO SEE MORE BOOKS ABOUT

I PURCHASE [] **BOOKS PER YEAR**

ADDITIONAL COMMENTS

FAX to: 1-800-622-3298

Place
Postage
Here

Name_____
Address_____
City_____State_____
Zip_____ — _____

Amherst Media, Inc.
PO Box 586
Buffalo, NY 14226